ROCKPORT
PUBLISHERS

Rockport Publishers, Rockport, Massachusetts

First published in the United States of America by:
Rockport Publishers, Inc.
146 Granite Street
Rockport, Massachusetts 01966-1299
Telephone: (508) 546-9590
Fax: (508) 546-7141

Distributed to the book trade and art trade in the United States by:
North Light, an imprint of
F & W Publications
1507 Dana Avenue
Cincinnati, Ohio 45207
Telephone: (513) 531-2222

Other Distribution by:
Rockport Publishers, Inc.
Rockport, Massachusetts 01966-1299

ISBN 1-56496-178-8

10 9 8 7 6 5 4 3 2 1

Design: Marc English: Design
Design Layout/Production: Beth Santos Design
Cover Icons: Beth Santos Design

Manufactured in Hong Kong

TABLE OF CONTENTS

INTRODUCTION

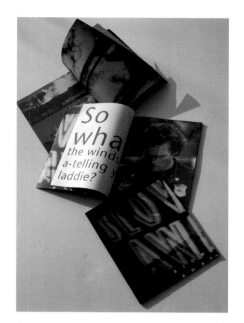

A motion picture has no shelf life. If nobody comes to see it the first day it's on the market, the party is over. In the movie business, ticket sales only go down, they never go up. Waterworld cost $200,000,000 to make. Prints, promotion, and advertising could use up another $100,000,000. This film, and every movie production, is like a major corporation, with major costs and expenses, that has only one product and only one opportunity to sell that product. Understandably, everyone involved is nervous.

You as a designer have just been asked by these nervous folks to create an icon which will convince at least 50,000,000 people to buy this product--that's about $300,000,000 in ticket sales which is about what Jurassic Park made. To start, at least 100 concepts from you and other designers will be revealed at a first stage presentation to the marketing department of the studio. Your idea will journey to at least six more meetings and could be revised (by you or by marketing people, the producer, or even a relative) at any stop along this route through the kingdoms of motion picture advertising, management, production, and actors with the power of approval. There could be possible side excursions to consumer research for your design before it's even considered good enough for stage-two meetings.

Six more stages of creative development might happen before we have a winner. Each stage will probably have to be created and produced overnight. If some form of your symbol survives this trip and is selected to be finished, hopefully you will get to finish it. To print your design as a poster, you will have to put this Frankenstein of yours into a rigid format. A format designed by contracts, advertising tactics, and movie audiences.

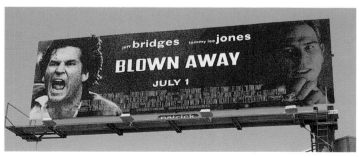

Entertainment lawyers make sure their clients get credited on the movie posters and advertisements in order of their earning power or the power of their guilds. Advertising demands a copyline on the poster and of course there must be a title. All of this information is set in type which has to be designed as carefully as your icon is designed.

Movie consumers make sure that every poster has the copy line at the top, the title two thirds of the way down the poster, with the legal credits of the people involved in the marketing and distributing the epic at the bottom. "If it ain't in that arrangement it can't be a movie" is how they tell it in the focus groups.

The good news is that movie graphics are important and they are getting better. In this book are some examples of the best. To have survived the big swim up river through so many obstacles means they are very good indeed.

Mike Salisbury
Mike Salisbury Communications, Torrance, CA

BRAD PITT JULIETTE LEWIS

POLYGRAM FILMED ENTERTAINMENT PRESENTS IN ASSOCIATION WITH VIACOM PICTURES A PROPAGANDA FILMS PRODUCTION

KALIFORNIA

Fear never travels alone.

A FILM BY DOMINIC SENA BRAD PITT JULIETTE LEWIS "KALIFORNIA" DAVID DUCHOVNY MICHELLE FORBES
EXECUTIVE PRODUCERS LYNN BIGELOW JIM LOUF MUSIC BY CARTER BURWELL EDITOR MARTIN HUNTER DIRECTOR OF PHOTOGRAPHY BOJAN BAZELLI
STORY BY STEPHEN LEVY & TIM METCALFE SCREENPLAY BY TIM METCALFE PRODUCED BY STEVE GOLIN
SIGURJON SIGHVATSSON AND ARISTIDES McGARRY DIRECTED BY DOMINIC SENA PolyGram

R RESTRICTED
UNDER 17 REQUIRES ACCOMPANYING
PARENT OR ADULT GUARDIAN

GRAMERCY

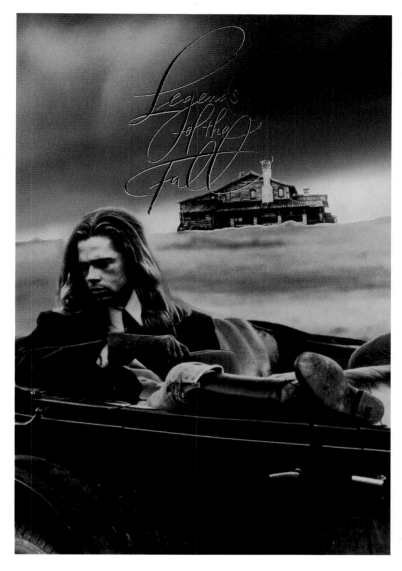

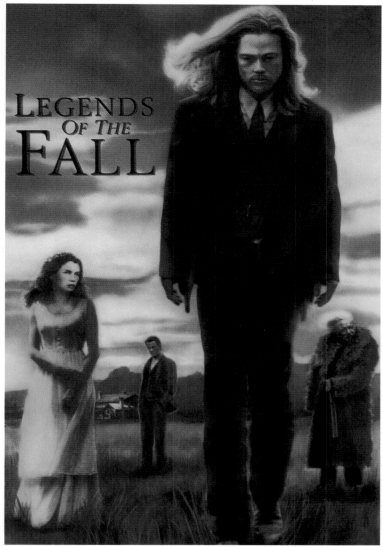

Kalifornia

MOVIE COMPANY

Polygram Filmed Entertainment

DISTRIBUTOR OF FILM

Gramercy Pictures

DESIGN FIRM

Aspect Ratio

ART DIRECTORS

Samantha Hart, Christian Struzen

DESIGNER

Christian Struzen

PHOTOGRAPHER

Philip Dixon

The designers used a 5-color printing process for this graphic.

Legends of the Fall

MOVIE COMPANY

TriStar Pictures

DISTRIBUTOR OF FILM

TriStar Pictures

DESIGN FIRM

Mike Salisbury Communications Inc.

ART DIRECTOR

Mike Salisbury

DESIGNER

Mike Salisbury

PHOTOGRAPHER

Herb Ritts

ILLUSTRATOR/ARTIST

Pat Linse

Designers used airbrush over hand-composited film stills.

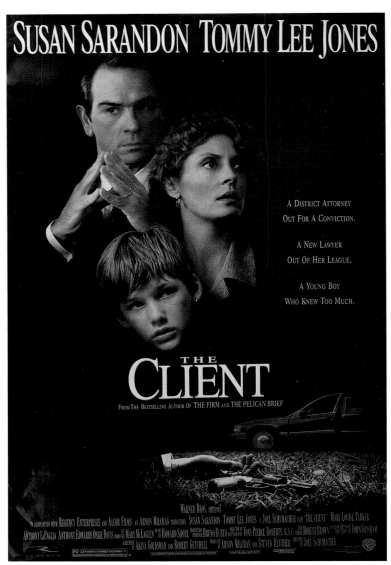

The Client

MOVIE COMPANY
Regency Enterprises
DISTRIBUTOR OF FILM
Warner Bros.
DESIGN FIRM
BLT & Associates Inc.
ART DIRECTOR
BLT & Associates Inc.
DESIGNER
BLT & Associates Inc.
PHOTOGRAPHERS
Demmi Todd, Todd Haiman
DIGITAL IMAGING
BLT & Associates Inc.

The designers developed this five-color image with a special hit of metallic gold.

The Firm, standee

MOVIE COMPANY
Paramount
DISTRIBUTOR OF FILM
Paramount
DESIGN FIRM
JJ&A
ART DIRECTOR
Aniko Kiezel
DESIGNER
Seiniger & Associates

The creators of this standee used two fluorescent lights to illuminate this four-color design.

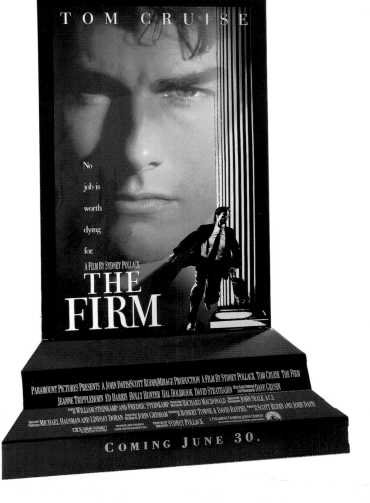

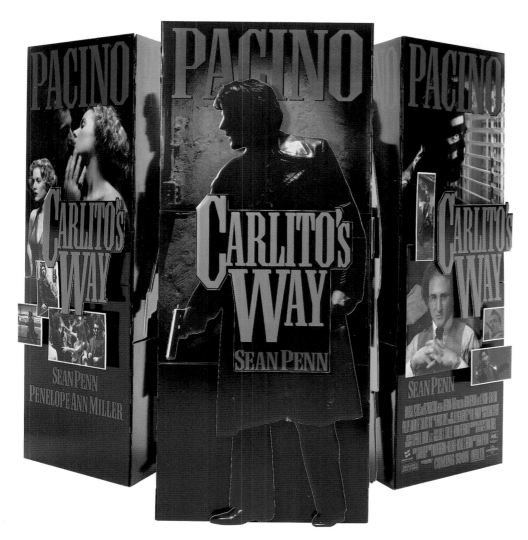

Carlito's Way, standee
MOVIE COMPANY
Universal Pictures
DISTRIBUTOR OF FILM
Universal Pictures
DESIGN FIRM
JJ&A
ART DIRECTOR
Tom Martin

The designers created a three-sided standee using a four-color image laminated to corrugated board and foam board.

To Be Number One
MOVIE COMPANY
Golden Harvest
DISTRIBUTOR OF FILM
Golden Harvest
DESIGN FIRM
PPA Design Limited
ART DIRECTOR
Byron Jacobs
DESIGNER
Nick Rhodes

The typography and artwork were hand-drawn, then scanned in and illustrated on Quantel Paintbox®. The title art was applied to lobby cards and posters.

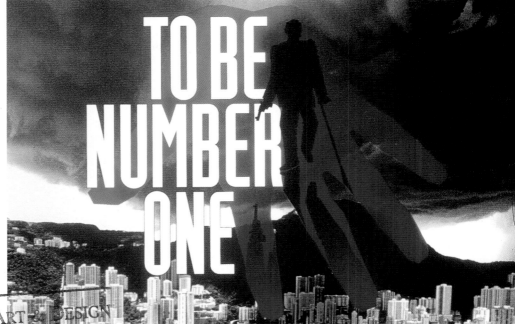

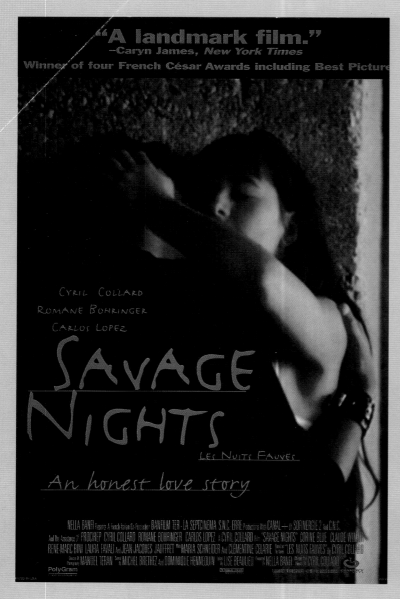

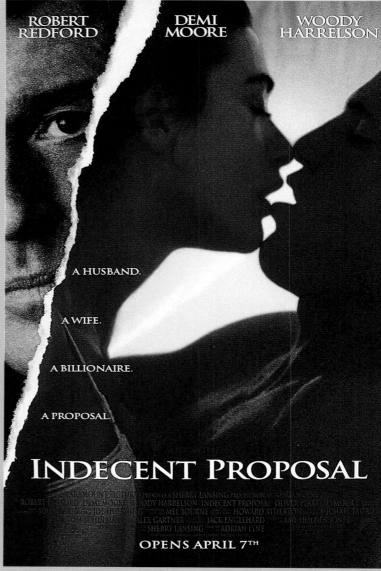

Savage Nights

MOVIE COMPANY

Polygram Filmed Entertainment

DISTRIBUTOR OF FILM

Gramercy Pictures

DESIGN FIRM

BRD Design

ART DIRECTORS

Samantha Hart, Peter King
Robbins

DESIGNER

Peter King Robbins

The image for this graphic was
retouched and posterized on a
Macintosh with the use of
Adobe Photoshop.

Indecent Proposal

MOVIE COMPANY

Paramount Pictures

DESIGN FIRM

Frankfurt Balkind Partners

ART DIRECTOR

Randi Braun

DESIGNER

Randi Braun

CREATIVE DIRECTOR

Peter Bemis

Designers manipulated a ripped
Xerox then spray-mounted it to a
black and white Xerox. The finished
art was done on Quantel Paintbox®.

Johnny Handsome, poster

MOVIE COMPANY
MGM

DISTRIBUTOR OF FILM
MGM

DESIGN FIRM
Mike Salisbury Communications Inc.

ART DIRECTOR
Mike Salisbury

DESIGNER
Terry Lamb

ILLUSTRATOR/ARTIST
Rod Dyer

The design was illustrated by hand from photographs.

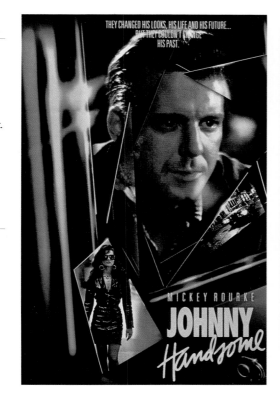

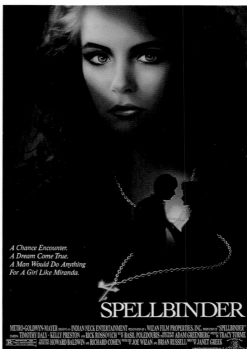

Spell Binder, poster

MOVIE COMPANY
MGM

DISTRIBUTOR OF FILM
MGM

DESIGN FIRM
Mike Salisbury Communications Inc.

ART DIRECTORS
Rick Loper, Mike Salisbury

DESIGNER
Mike Salisbury

ILLUSTRATOR/ARTIST
Jeff Wack

This graphic was created using airbrush over photography.

Dolores Claiborne

MOVIE COMPANY
Castle Rock Entertainment

DISTRIBUTOR OF FILM
Columbia Pictures

DESIGN FIRM
Frankfurt Balkind Partners

CREATIVE DIRECTOR
Peter Bemis

DESIGNERS
Brett Wickens, Kim Wexman

ILLUSTRATOR/ARTIST
Emerald City

Photographic elements were scanned and input in to a Silicon Graphics workstation, composed, color-manipulated, and grained for effect.

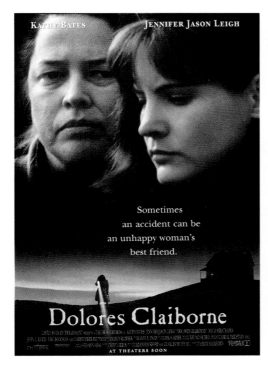

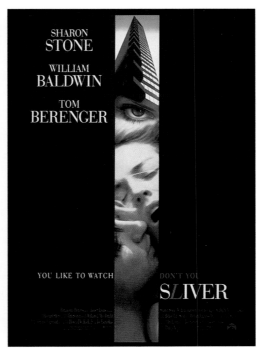

Sliver

MOVIE COMPANY
Paramount Pictures

DESIGN FIRM
Frankfurt Balkind Partners

ART DIRECTOR
Kim Wexman

DESIGNER
Kim Wexman

CREATIVE DIRECTOR
Peter Bemis

COPYWRITER
Kim Wexman

Three different scenes were merged together and cropped in the shape of a "sliver." Kim tried to keep the type minimal so as not to interfere with the concept of the sliver shape in the center.

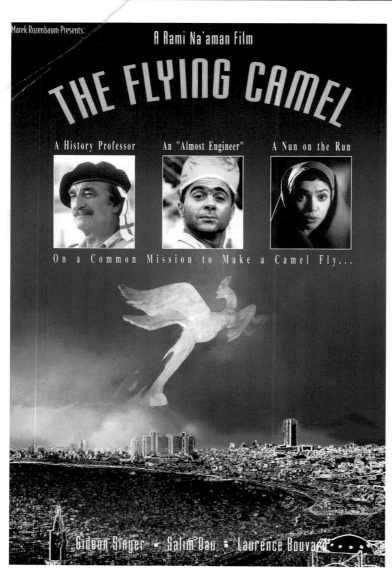

The Flying Camel

MOVIE COMPANY

Transfax Productions

DISTRIBUTOR OF FILM

Transfax Productions

DESIGN FIRM

Yesh!

ART DIRECTOR

Yehudith Schatz

DESIGNER

Yehudith Schatz

PHOTOGRAPHER

Jacky Matitiahu

ILLUSTRATOR/ARTIST

Yehudith Schatz

Three stills of the leading actors were scanned, and the background was a scan of a Tel-Aviv postcard and still of a camel sculpture. All design was completed in Adobe Photoshop on a Macintosh Quadra 650. The "Tel-Aviv" portion of the background came to life with the "find edges" filter and with the negative inversion of the camel pasted into paint-brushed background.

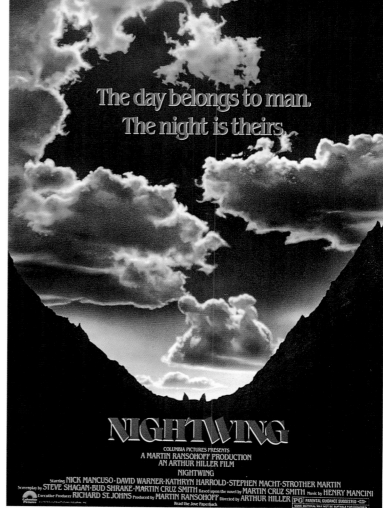

Nightwing

MOVIE COMPANY

Columbia Pictures

DISTRIBUTOR OF FILM

Columbia Pictures

DESIGN FIRM

Mike Salisbury Communications Inc.

ART DIRECTOR

Mike Salisbury

DESIGNER

Mike Salisbury

ILLUSTRATOR/ARTIST

Joe Heiner

Design developed by airbrush over photography.

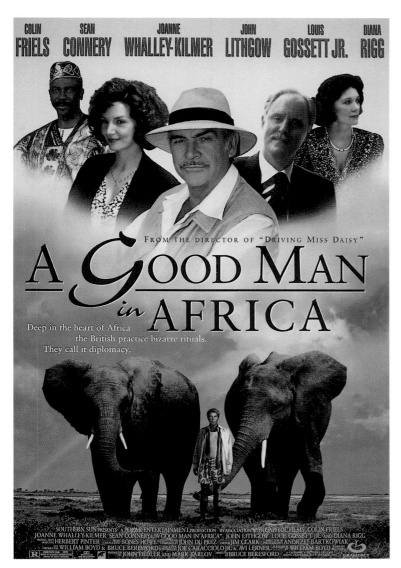

A Good Man in Africa

MOVIE COMPANY

Universal Pictures

DISTRIBUTOR OF FILM

Gramercy Pictures

DESIGN FIRM

BRD Design

ART DIRECTOR

Neville Burtis

DESIGNER

Neville Burtis

Designers composited the majority of imagery from the unit in Quantel Paintbox®.

A Home of Our Own

MOVIE COMPANY

Polygram Filmed Entertainment

DISTRIBUTOR OF FILM

Gramercy Pictures

DESIGN FIRM

BRD Design

ART DIRECTORS

Tabitha Delatorre, Peter King Robbins

DESIGNER

Peter King Robbins

Photographers used a body double for actress Kathy Bates and stripped the image of the model's head in Quantel Paintbox®. The window was part of the body-double shoot and the images of children were composited in Quantel Paintbox®.

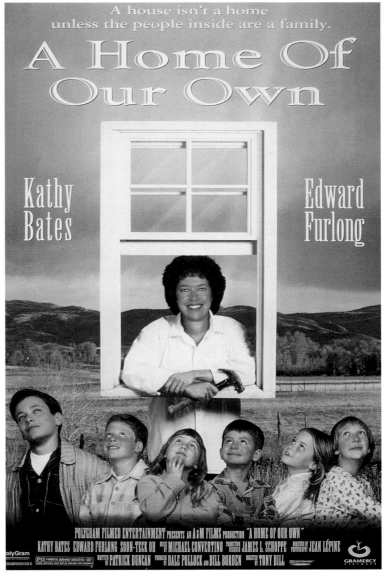

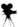

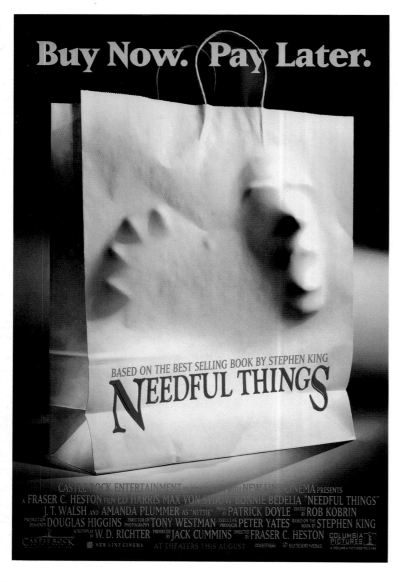

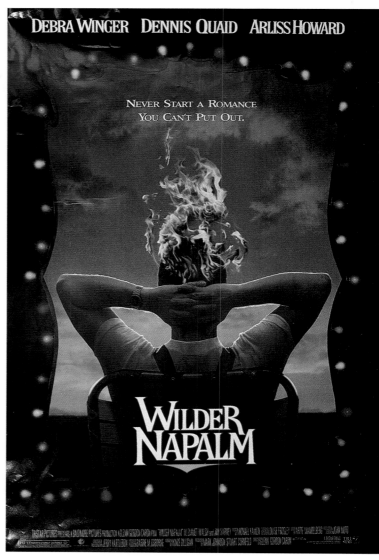

Needful Things

MOVIE COMPANY

Castle Rock Entertainment

DISTRIBUTOR OF FILM

Columbia Pictures

DESIGN FIRM

Frankfurt Balkind Partners

ART DIRECTOR

Charles Reimers

DESIGNER

Charles Reimers

PHOTOGRAPHER

Jack Anderson

CREATIVE DIRECTOR

Peter Bemis

COPYWRITER

Peter Bemis

To create the face and hand, a plastic cast was made and photographed, along with a shopping bag. Both were photographed in the same lighting set-up. The face and bag were composed and retouched on Quantel Paintbox®.

Wilder Napalm

MOVIE COMPANY

Baltimore Pictures

DISTRIBUTOR OF FILM

TriStar Pictures

DESIGN FIRM

BLT & Associates Inc.

ART DIRECTOR

BLT & Associates Inc.

DESIGNER

BLT & Associates Inc.

PHOTOGRAPHER

Pete Tangen

DIGITAL IMAGING

Digital Transparency

The designers used a 4-color printing process for this image.

'Mother?'

Just when you were beginning to forget.

PSYCHO II

ANTHONY PERKINS "PSYCHO II" VERA MILES MEG TILLY ROBERT LOGGIA
Written by TOM HOLLAND Based on characters created by ROBERT BLOCH Director of Photography DEAN CUNDY
Executive Producer BERNARD SCHWARTZ Produced by HILTON A. GREEN Directed by RICHARD FRANKLIN A BERNARD SCHWARTZ PRODUC
A UNIVERSAL-OAK PICTURE © 1982 UNIVERSAL CITY STUDIOS, INC.

Psycho II

MOVIE COMPANY
Universal

DISTRIBUTOR OF FILM
Universal

DESIGN FIRM
Mike Salisbury Communications Inc.

ART DIRECTOR
Mike Salisbury

DESIGNER
Mike Salisbury

PHOTOGRAPHER
Steve Harvey

The designers superimposed a photo of "mother" over the photo of Anthony Perkins for this image.

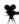

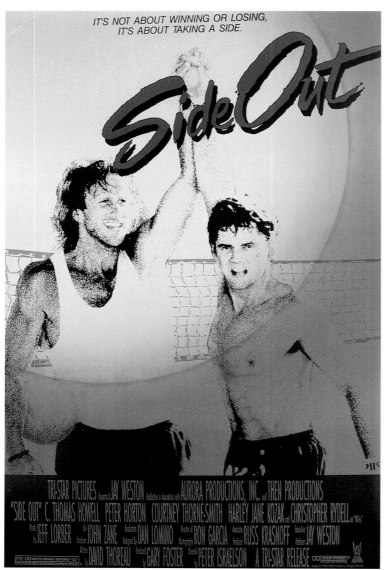

Side Out, poster

MOVIE COMPANY

TriStar Pictures

DESIGN FIRM

Mike Salisbury Communications Inc.

ART DIRECTOR

Mike Salisbury

DESIGNER

Mike Salisbury

ILLUSTRATORS/ARTISTS

Terry Lamb, Brian Sisson

High-resolution and Xeroxed film were positioned over an airbrush drawing for this image.

Year of the Dragon

MOVIE COMPANY

MGM

DISTRIBUTOR OF FILM

MGM

DESIGN FIRM

Mike Salisbury Communications Inc.

ART DIRECTOR

Mike Salisbury

DESIGNER

Mike Salisbury

ILLUSTRATOR/ARTIST

Jeff Wack

The character for the dragon was hand-painted on a color print of a frame from the movie.

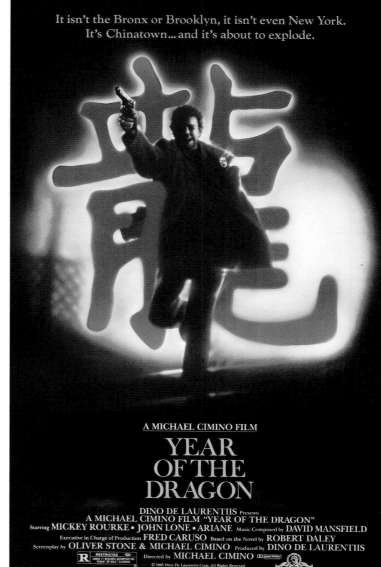

Big Trouble in Little China, sign

MOVIE COMPANY

Twentieth Century Fox

DISTRIBUTOR OF FILM

Twentieth Century Fox

DESIGN FIRM

Mike Salisbury Communications Inc.

ART DIRECTOR

Mike Salisbury

DESIGNER

Terry Lamb

ILLUSTRATOR/ARTIST

Terry Lamb

This 12-foot-high neon sign was created from computer renderings.

Farewell China

MOVIE COMPANY

Golden Harvest

DISTRIBUTOR OF FILM

Golden Harvest

DESIGN FIRM

PPA Design Limited

ART DIRECTOR

Byron Jacobs

DESIGNER

Nick Rhodes

The typography and artwork was created in Aldus Freehand then scanned in and illustrated on Quantel Paintbox®. All materials were printed offset, and the title art was applied to lobby cards and posters.

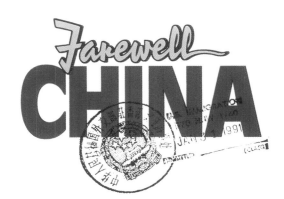

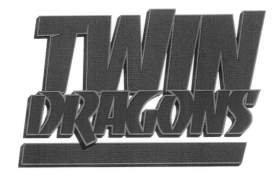

Twin Dragons

MOVIE COMPANY

Golden Harvest

DISTRIBUTOR OF FILM

Golden Harvest

DESIGN FIRM

PPA Design Limited

ART DIRECTOR

Byron Jacobs

DESIGNER

Byron Jacobs

The typography and artwork was created in Aldus Freehand, then scanned in and illustrated on Quantel Paintbox®.

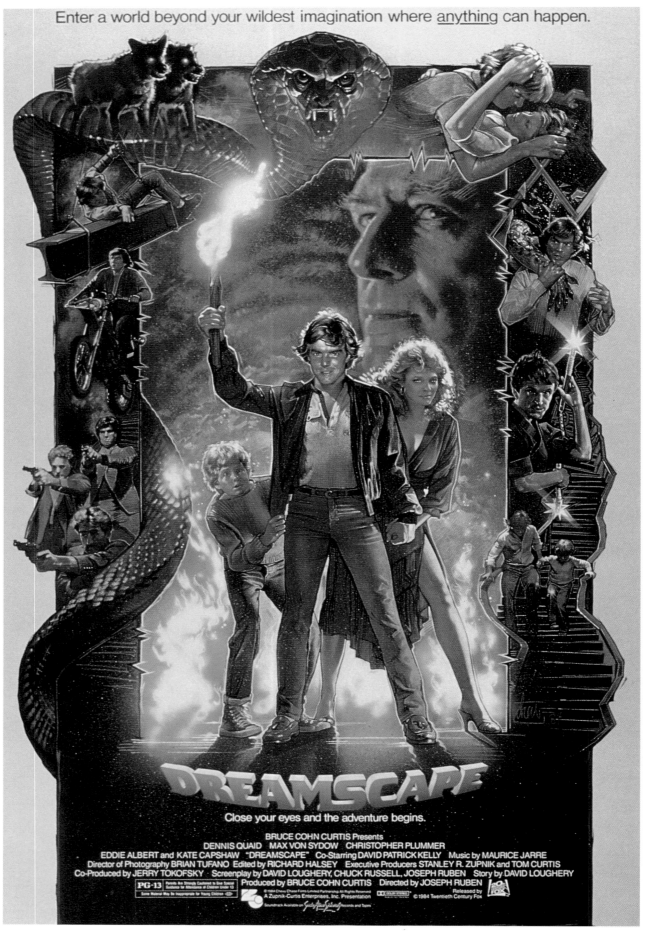

Dreamscape, poster
MOVIE COMPANY
Twentieth Century Fox
DISTRIBUTOR OF FILM
Twentieth Century Fox
DESIGN FIRM
Mike Salisbury Communications Inc.
ART DIRECTOR
Mike Salisbury
DESIGNERS
Terry Lamb, Dru Struzan
ILLUSTRATOR/ARTIST
Dru Struzan

Elements of this graphic were illustrated by hand.

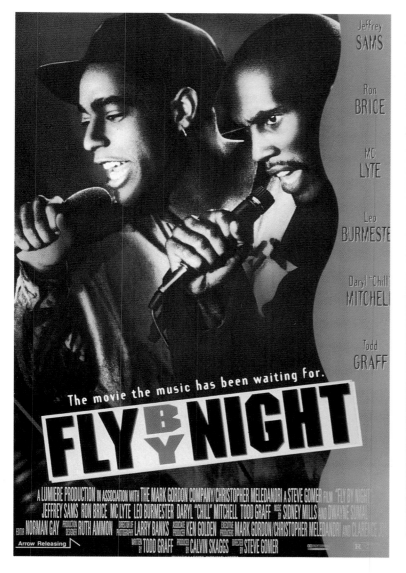

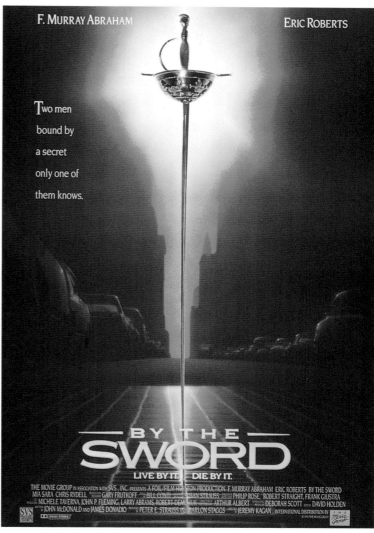

Fly by Night

MOVIE COMPANY
Columbia TriStar Home Video
DISTRIBUTOR OF FILM
Showtime
DESIGN FIRM
Dawn Patrol
ART DIRECTOR
Jimmy Wachtel
DESIGNER
Victor Martin
ILLUSTRATOR/ARTIST
Rick Monzon

A fifth color, Dayglo orange, was added to this four-color design created with hand-painted photographs.

By the Sword

MOVIE COMPANY
The Movie Group
DESIGN FIRM
Dawn Patrol
ART DIRECTOR
Jimmy Wachtel
DESIGNERS
Jimmy Wachtel, Jim Kelly
PHOTOGRAPHER
Nels Israelson
ILLUSTRATOR/ARTIST
John Alvin
COPYWRITER
Deb Scott

This silver logo was developed with the use of two photographs that were montaged and then painted over.

The Good Son

MOVIE COMPANY

Twentieth Century Fox (International)

DISTRIBUTOR OF FILM

Twentieth Century Fox (International)

DESIGN FIRM/AGENCY

Frankfurt Balkind Partners

ART DIRECTOR

Rima Sinno

DESIGNERS

Rima Sinno, Robert Rainey

CREATIVE DIRECTOR

Peter Bemis

Image was converted to a blue duotone, using a gaussin blur on the whole face except for the eye, which allowed the eye to stand out.

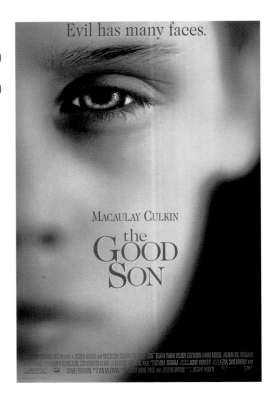

Natural Born Killers

MOVIE COMPANY

Regency Enterprises

DISTRIBUTOR OF FILM

Warner Bros.

DESIGN FIRM

BLT & Associates Inc.

ART DIRECTOR

BLT & Associates Inc.

DESIGNER

BLT & Associates Inc.

PHOTOGRAPHER

Sidney Baldwin

DIGITAL IMAGING

BLT & Associates Inc.

The designers used red and yellow accents on this six-color design.

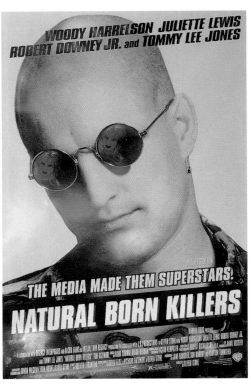

Sleeping with the Enemy, poster

MOVIE COMPANY

Twentieth Century Fox

DISTRIBUTOR OF FILM

Twentieth Century Fox

DESIGN FIRM

Mike Salisbury Communications Inc.

ART DIRECTOR

Chris Pula

DESIGNER

Mike Salisbury

This concept was executed in print from a television trailer.

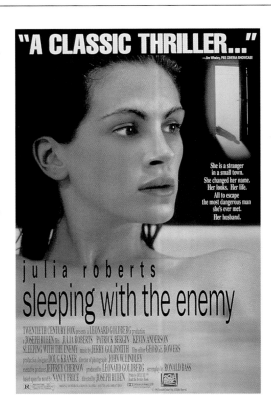

Poltergeist III, standee

MOVIE COMPANY

MGM

DISTRIBUTOR OF FILM

MGM

DESIGN FIRM/AGENCY

Mike Salisbury Communications Inc.

ILLUSTRATORS/ARTISTS

Jeff Wack, Pat Linse

The design elements for this standee were hand-assembled and hand-painted.

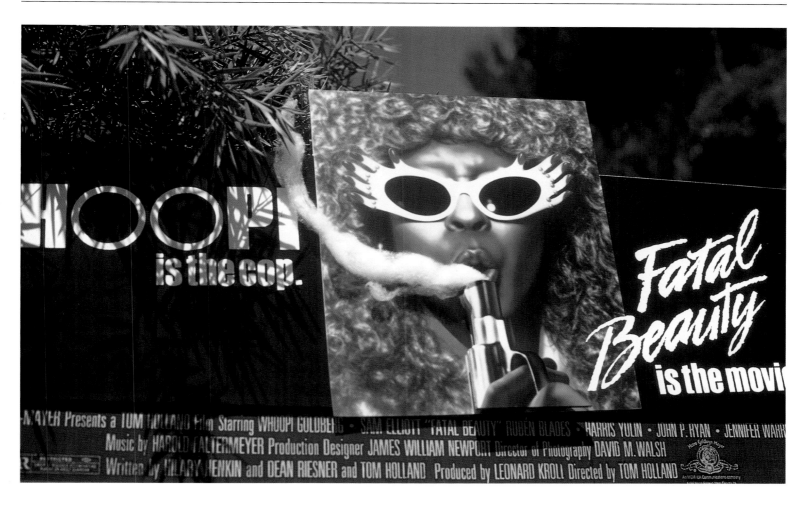

NMYER Presents a TOM HOLLAND Film Starring WHOOPI GOLDBERG · SAM ELLIOTT "FATAL BEAUTY" RUBEN BLADES · HARRIS YULIN · JOHN P. RYAN · JENNIFER WARR Music by HAROLD FALTERMEYER Production Designer JAMES WILLIAM NEWPORT Director of Photography DAVID M. WALSH Written by HILARY HENKIN and DEAN RIESNER and TOM HOLLAND Produced by LEONARD KROLL Directed by TOM HOLLAND

Fatal Beauty

MOVIE COMPANY
MGM
DISTRIBUTOR OF FILM
MGM
DESIGN FIRM
Mike Salisbury Communications Inc.
ART DIRECTOR
Mike Salisbury
DESIGNER
Terry Lamb
ILLUSTRATOR/ARTIST
Jeff Wack

The hand and gun in this image were stripped into the head shot, and the lips were created by hand.

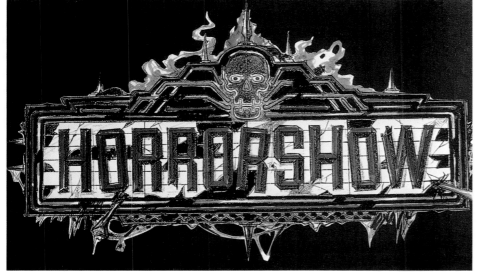

Horror Show

MOVIE COMPANY
MGM
DISTRIBUTOR OF FILM
MGM
DESIGN FIRM
Mike Salisbury Communications Inc.
ART DIRECTOR
Mike Salisbury
DESIGNER
Terry Lamb

The movie title graphics were created from a rough drawing.

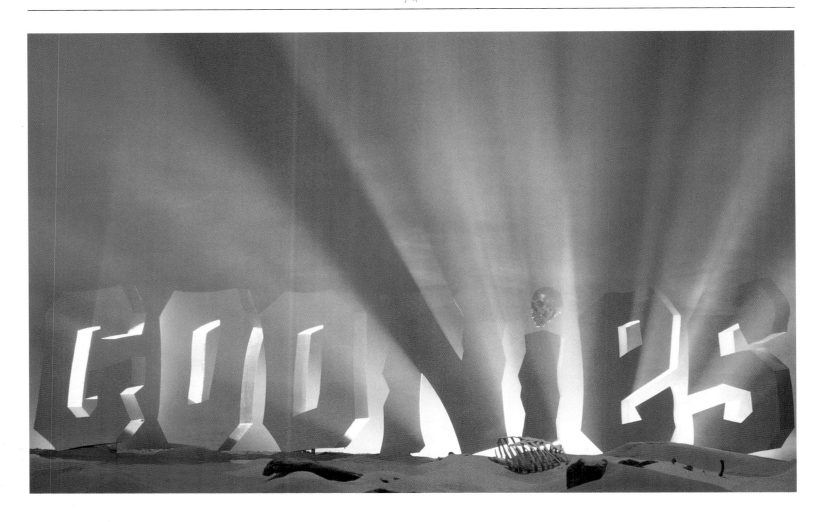

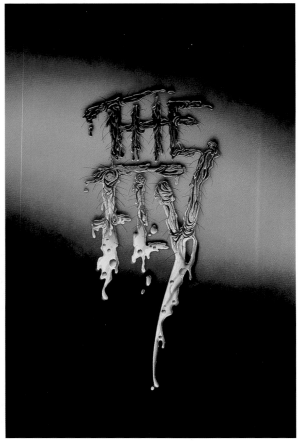

The Fly

MOVIE COMPANY

Twentieth Century Fox

DISTRIBUTOR OF FILM

Twentieth Century Fox

DESIGN FIRM

Mike Salisbury Communications Inc.

ART DIRECTOR

Mike Salisbury

DESIGNER

Mike Salisbury

ILLUSTRATOR/ARTIST

Bruce Eagle

The designers of this logo animated it
by making the letters drip and hair
grow as the light passed in sweeps
over the letter forms.

The Goonies,
live effects trailer title

MOVIE COMPANY

Warner Bros.

DISTRIBUTOR OF FILM

Warner Bros.

DESIGN FIRM

Mike Salisbury Communications Inc.

ART DIRECTOR

Mike Salisbury

DESIGNERS

Mike Salisbury, Terry Lamb

The designers sculpted the skull form.
It was lit from behind as the skull
twirled into view.

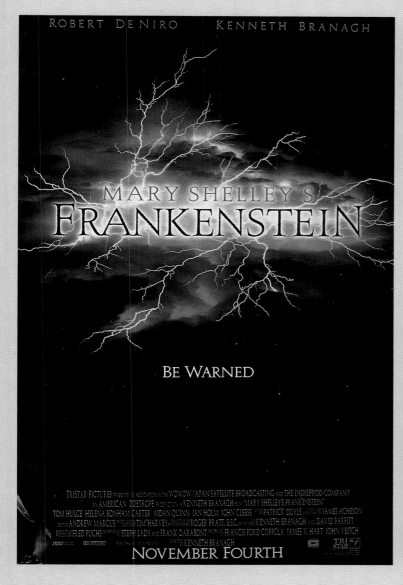

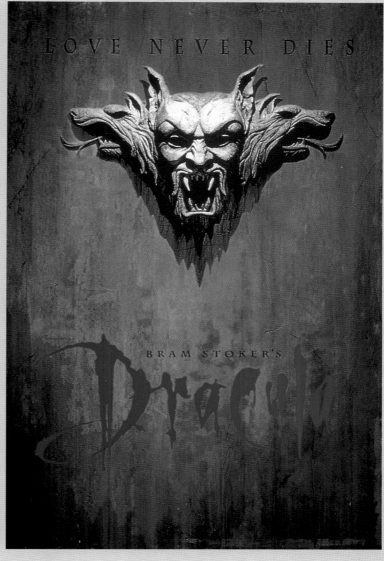

Frankenstein

MOVIE COMPANY

TriStar Pictures

DISTRIBUTOR OF FILM

TriStar Pictures

DESIGN FIRM

BLT & Associates Inc.

ART DIRECTOR

BLT & Associates Inc.

DESIGNER

BLT & Associates Inc.

ILLUSTRATOR/ARTIST

BLT & Associates Inc.

The designers used a special blue touch plate with this five-color image.

Francis Ford Coppola's
Bram Stoker's Dracula

MOVIE COMPANY

Columbia Pictures

DISTRIBUTOR OF FILM

Columbia Pictures

DESIGN FIRM

Margo Chase Design

CREATIVE DIRECTOR

John Kehe

ART DIRECTOR

Margo Chase

LETTERING DESIGNER

Nancy Ogami

PHOTOGRAPHER

Sidney Cooper

SCULPTOR

Jaqueline Perrault

The logo was drawn by hand using a crow-quill pen, and was scanned into the computer and manipulated in Adobe Illustrator. The gargoyle was sculpted in 3-D, mounted on a painted plaster background and photographed. The photo was then scanned and retouched on the computer.

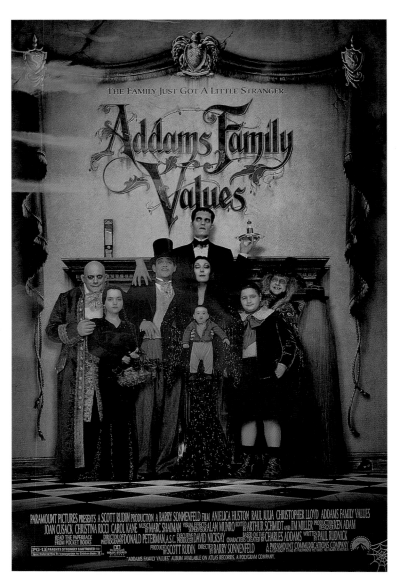

Addams Family Values

MOVIE COMPANY

Paramount Pictures

DISTRIBUTOR OF FILM

Paramount Pictures

DESIGN FIRM

BLT & Associates Inc.

ART DIRECTOR

BLT & Associates Inc.

DESIGNER

BLT & Associates Inc.

PHOTOGRAPHERS

Firooz Zahedi, Pete Tangen

ILLUSTRATOR/ARTIST

Mark Ryden

The creators added a special hit of gold to this five-color design.

Addams Family Values, standee

MOVIE COMPANY

Paramount Pictures

DISTRIBUTOR OF FILM

Paramount Pictures

DESIGN FIRM

BLT & Associates Inc.

ART DIRECTOR

BLT & Associates Inc.

DESIGNER

BLT & Associates Inc.

PHOTOGRAPHERS

Firooz Zahedi, Nels Israelson

ILLUSTRATOR/ARTIST

Mark Ryden

PRODUCTION/ MANUFACTURING

Drissi Advertising

This design was developed four-color.

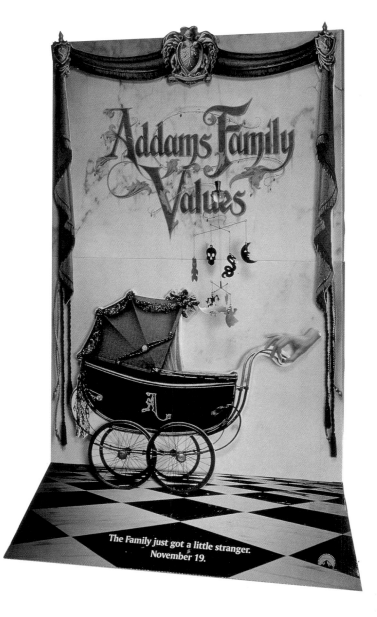

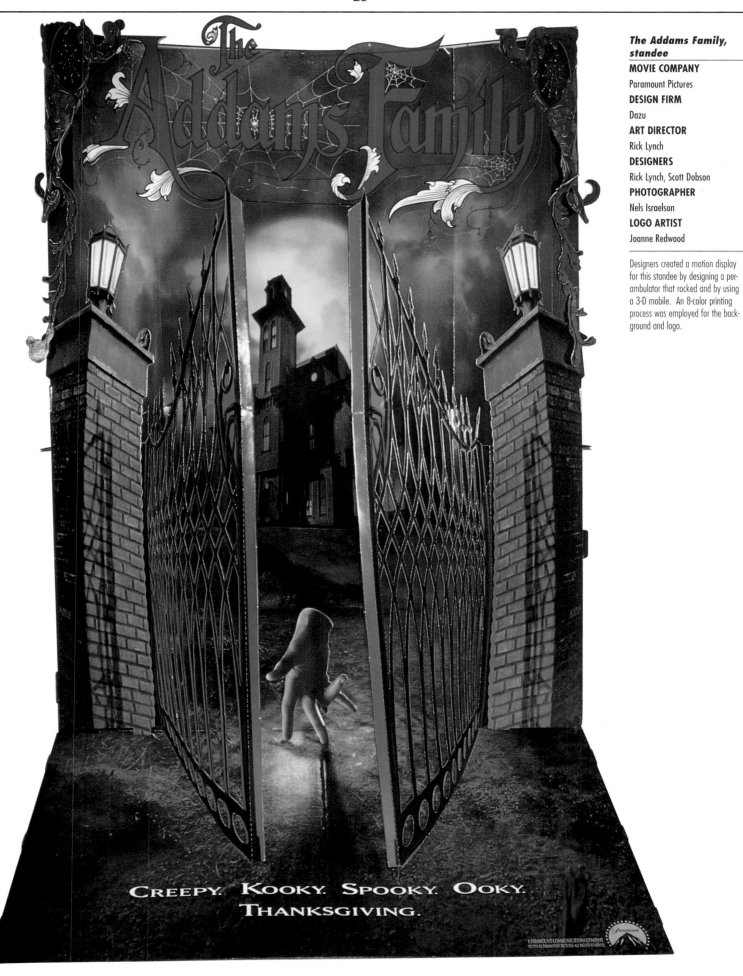

The Addams Family, standee

MOVIE COMPANY
Paramount Pictures
DESIGN FIRM
Dazu
ART DIRECTOR
Rick Lynch
DESIGNERS
Rick Lynch, Scott Dobson
PHOTOGRAPHER
Nels Israelson
LOGO ARTIST
Joanne Redwood

Designers created a motion display for this standee by designing a perambulator that rocked and by using a 3-D mobile. An 8-color printing process was employed for the background and logo.

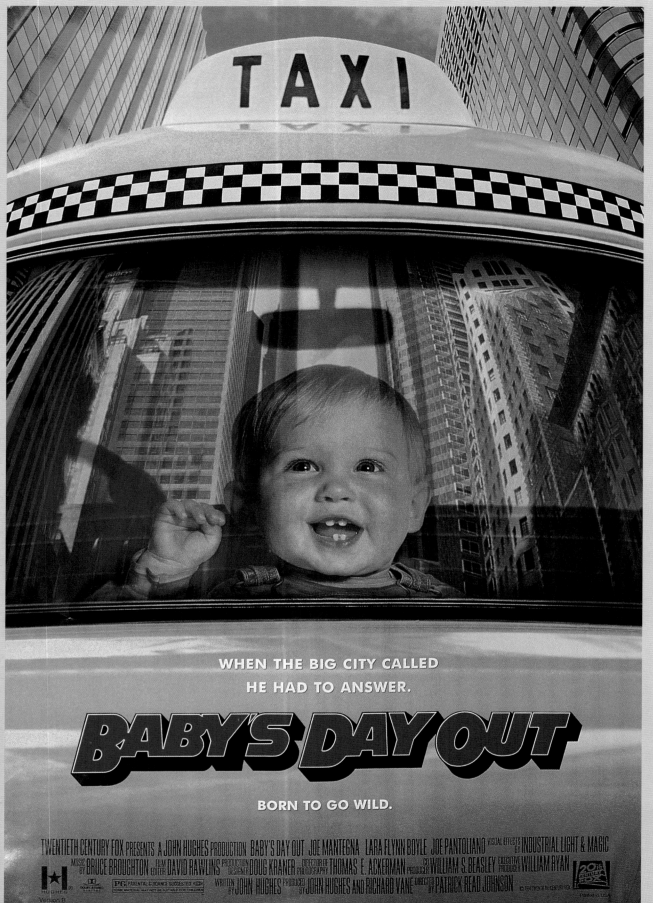

Baby's Day Out

MOVIE COMPANY
Hughes Entertainment

DISTRIBUTOR OF FILM
Twentieth Century Fox

DESIGN FIRM/AGENCY
BLT & Associates Inc.

ART DIRECTOR
BLT & Associates Inc.

DESIGNER
BLT & Associates Inc.

PHOTOGRAPHERS
Timothy White, Nels Israelson

DIGITAL IMAGING
Cronopious

A special hit of red and yellow was added by the creators to this six-color image.

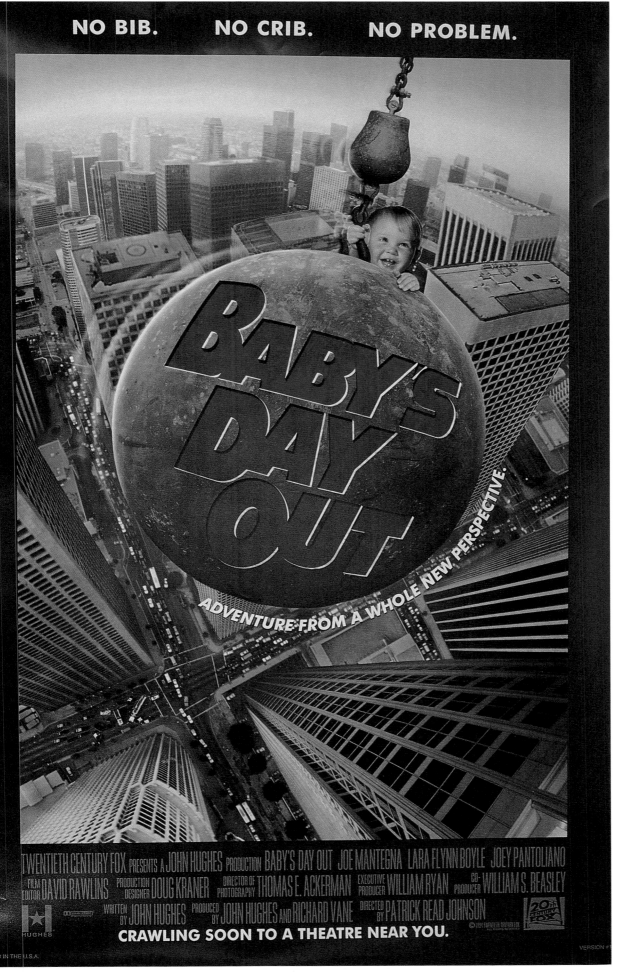

Baby's Day Out, teaser campaign

MOVIE COMPANY

Hughes Entertainment

DISTRIBUTOR OF FILM

Twentieth Century Fox

DESIGN FIRM

BLT & Associates Inc.

ART DIRECTOR

BLT & Associates Inc., Tom Martin

DESIGNER

BLT & Associates Inc.

PHOTOGRAPHERS

Timothy White, Pete Tangen

DIGITAL IMAGING

Imagic

This six-color teaser campaign has a special hit of red and yellow.

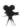

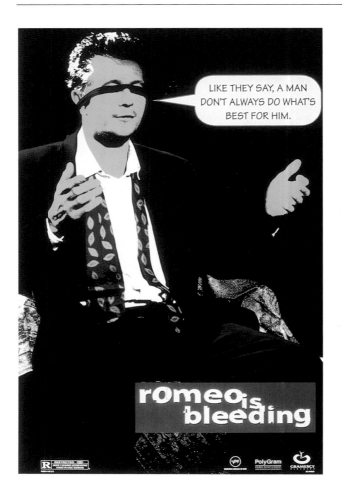

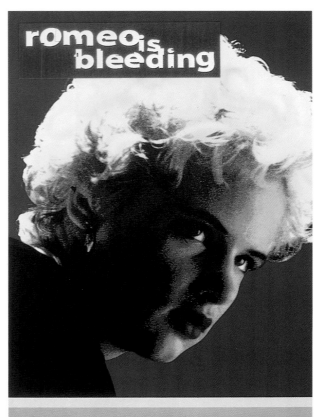

Romeo Is Bleeding, teaser campaign

MOVIE COMPANY

Polygram Filmed Entertainment

DISTRIBUTOR OF FILM

Gramercy Pictures

DESIGN FIRM

BRD Design

ART DIRECTORS

Samantha Hart, Peter King Robbins

DESIGNER

Peter King Robbins

Photography for this design was taken from the film and heavily retouched and posterized on Quantel Paintbox®.

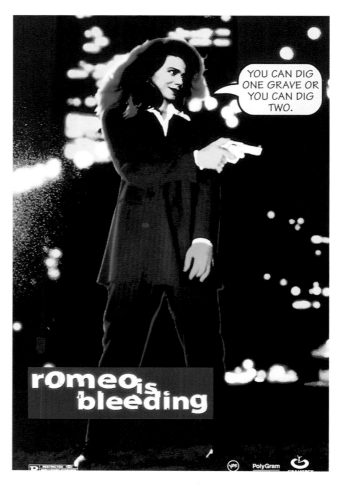

romeo is bleeding

The Story Of A Cop
Who Wanted It Bad
And Got It Worse

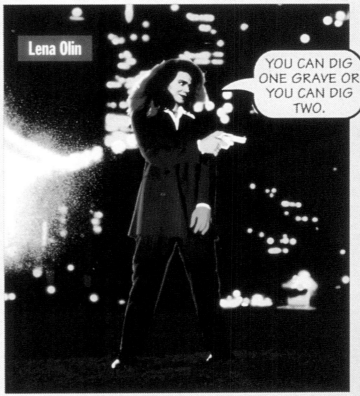

POLYGRAM FILMED ENTERTAINMENT PRESENTS A WORKING TITLE/HILARY HENKIN PRODUCTION
GARY OLDMAN LENA OLIN ANNABELLA SCIORRA AND JULIETTE LEWIS A PETER MEDAK FILM "ROMEO IS BLEEDING" AND ROY SCHEIDER
CASTING BY BONNIE TIMMERMAN MUSIC BY MARK ISHAM EDITED BY WALTER MURCH PRODUCTION DESIGNER STUART WURTZEL
DIRECTOR OF PHOTOGRAPHY DARIUSZ WOLSKI EXECUTIVE PRODUCERS TIM BEVAN AND ERIC FELLNER WRITTEN BY HILARY HENKIN
PolyGram R RESTRICTED PRODUCED BY HILARY HENKIN AND PAUL WEBSTER DIRECTED BY PETER MEDAK DOLBY STEREO Verve GRAMERCY

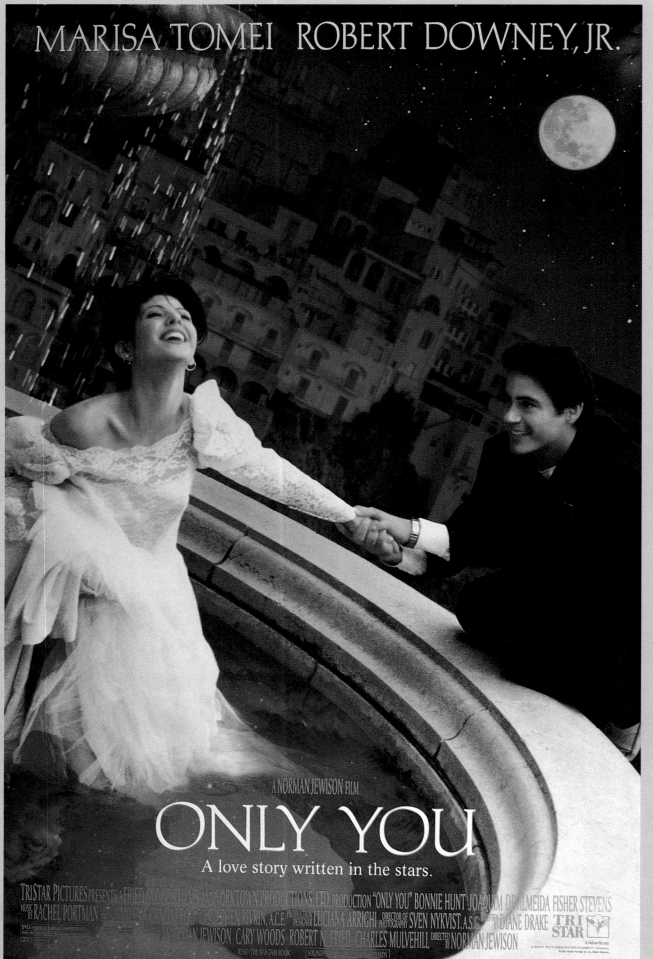

Only You

MOVIE COMPANY
TriStar Pictures

DISTRIBUTOR OF FILM
TriStar Pictures

DESIGN FIRM
BLT & Associates Inc.

ART DIRECTOR
BLT & Associates Inc.

DESIGNER
BLT & Associates Inc.

PHOTOGRAPHER
Timothy White

DIGITAL IMAGING
BLT & Associates Inc.

This six-color graphic was made with
a special gold accent.

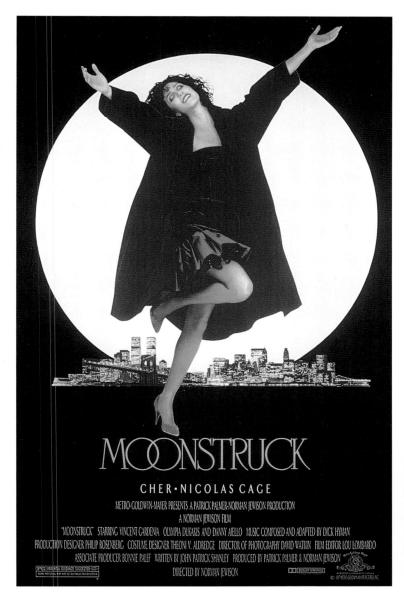

Moonstruck

MOVIE COMPANY

MGM

DISTRIBUTOR OF FILM

MGM

DESIGN FIRM

Mike Salisbury Communications Inc.

ART DIRECTOR

Mike Salisbury

DESIGNER

Tony Seiniger

PHOTOGRAPHER

Herb Ritts

Photography was based on original sketch drawings.

Four Weddings and a Funeral

MOVIE COMPANY

Polygram Filmed Entertainment

DISTRIBUTOR OF FILM

Gramercy Pictures

DESIGN FIRM

BRD Design

ART DIRECTOR

Samantha Hart

DESIGNERS

Neville Burtis, Peter King Robbins

This four-color design includes multiple photographs that were composited on Quantel Paintbox®.

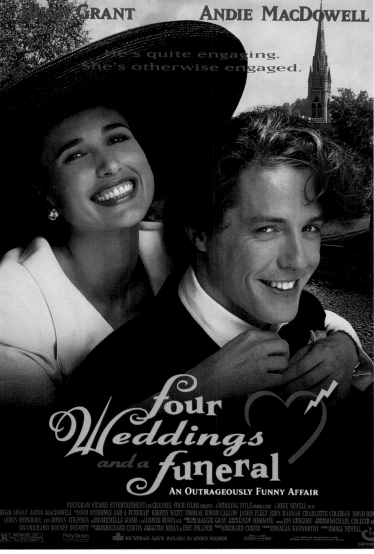

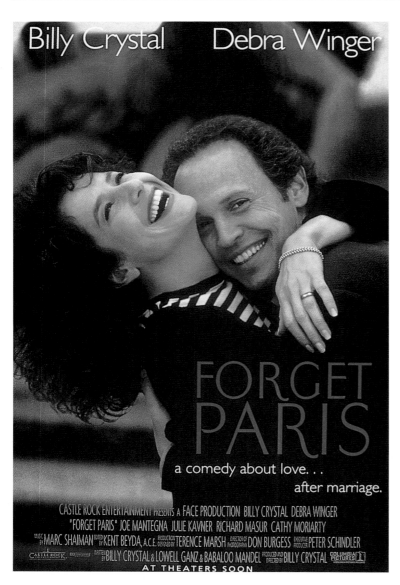

Forget Paris

MOVIE COMPANY

Castle Rock Entertainment

DISTRIBUTOR OF FILM

Columbia Pictures

DESIGN FIRM

Frankfurt Balkind Partners

CREATIVE DIRECTOR

Peter Bemis

DESIGNER

Jay LaRosa

PHOTOGRAPHER

Bruce McBroom

ILLUSTRATOR/ARTIST

Imagic

The designers scanned unit photography. They colorized and grained the image on a Power Macintosh 8100.

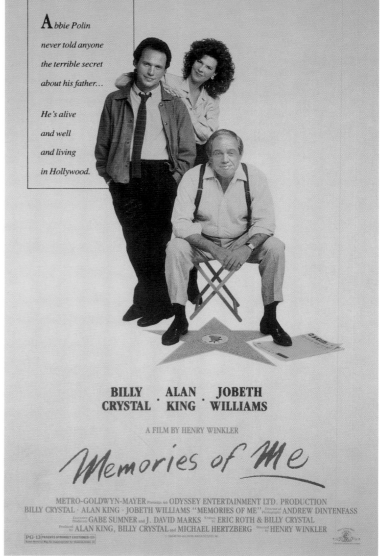

Memories of Me

MOVIE COMPANY

MGM

DISTRIBUTOR OF FILM

MGM

DESIGN FIRM

Mike Salisbury Communications Inc.

ART DIRECTORS

Greg Morrison, Mike Salisbury

DESIGNER

Mike Salisbury

PHOTOGRAPHER

Annie Liebowitz

Photography was based on designers concept sketches.

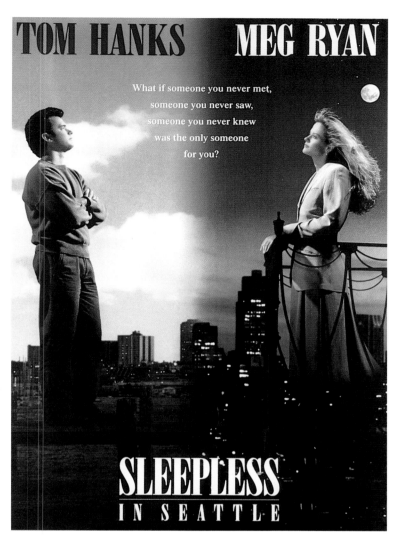

Sleepless in Seattle
MOVIE COMPANY
TriStar Pictures
DISTRIBUTOR OF FILM
TriStar Pictures
DESIGN FIRM
BLT & Associates Inc.
ART DIRECTOR
BLT & Associates Inc.
DESIGNER
BLT & Associates Inc.
PHOTOGRAPHER
Timothy White
DIGITAL IMAGING
Imagic

Designers used a 6-color process for this image.

Shadowlands
MOVIE COMPANY
Savoy Pictures Entertainment
DISTRIBUTOR OF FILM
Savoy Pictures Entertainment
AGENCY
B.D. Fox & Friends, Inc. Advertising
ART DIRECTORS
Cindy Luck, Garrett Burke,
Brian D. Fox
DESIGNER
Garrett Burke
PHOTOGRAPHER
Keith Hamshere
ILLUSTRATOR
Metafor
COPYWRITER
Kate Cox

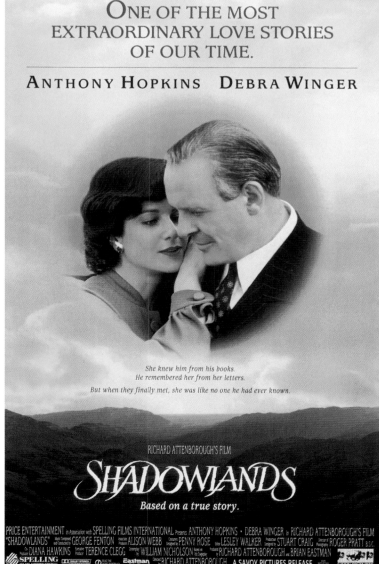

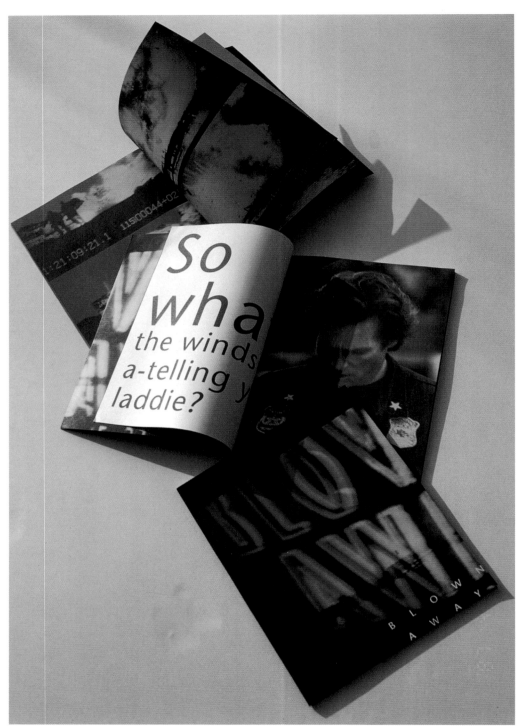

Blown Away
MOVIE COMPANY
MGM
DISTRIBUTOR OF FILM
MGM
DESIGN FIRM
Mike Salisbury Communications Inc.
ART DIRECTOR
Mike Salisbury
DESIGNERS
Patrick O'Neal, Mike Salisbury
PHOTOGRAPHERS
Bruce Birmezow, Joel D. Warren

Over 110,000 pictures were edited to create a book to promote this movie in a contemporary style. A vertical format was chosen to look different than most movie promotions, which are horizontal.

Leviathan
MOVIE COMPANY
MGM
DISTRIBUTOR OF FILM
MGM
DESIGN FIRM
Mike Salisbury Communications Inc.
ART DIRECTOR
Mike Salisbury
DESIGNERS
Mike Salisbury, Terry Lamb
ILLUSTRATOR/ARTIST
Terry Lamb

Design created with the use of airbrush and marker.

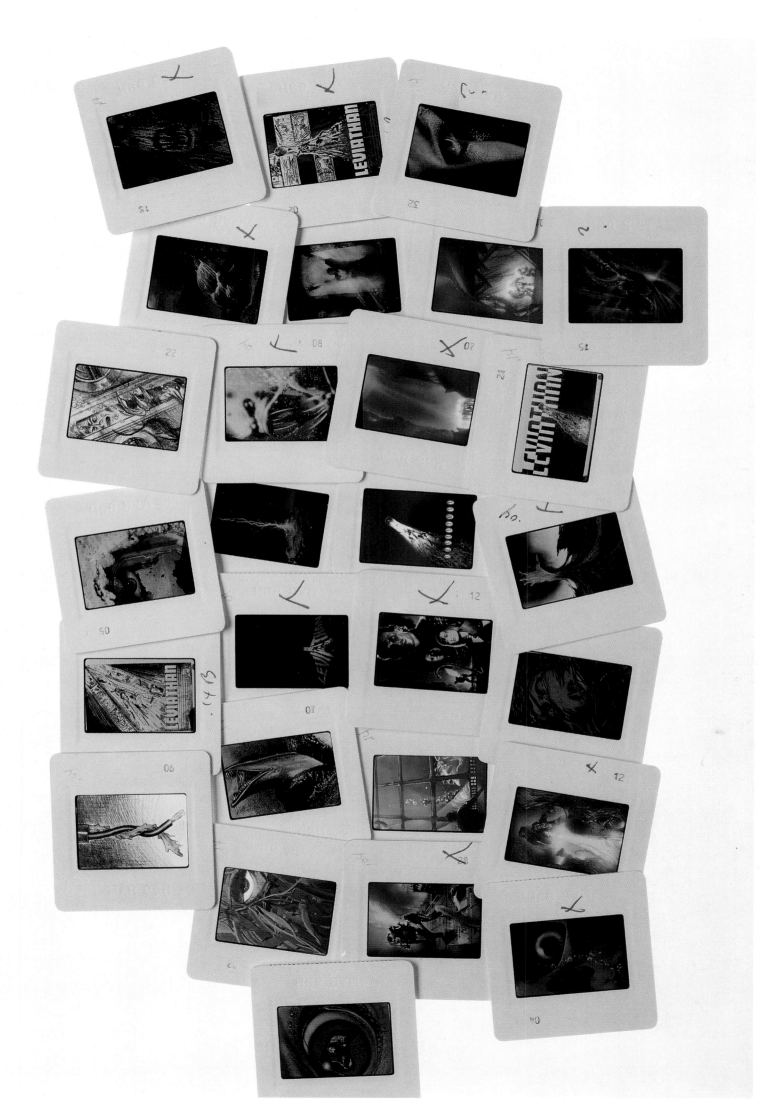

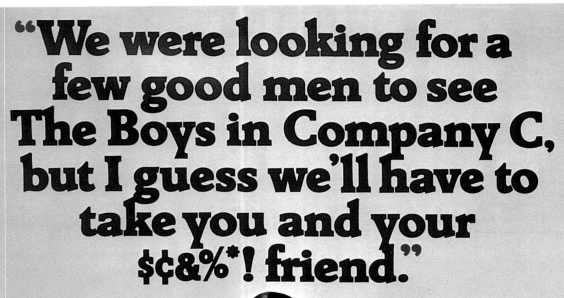

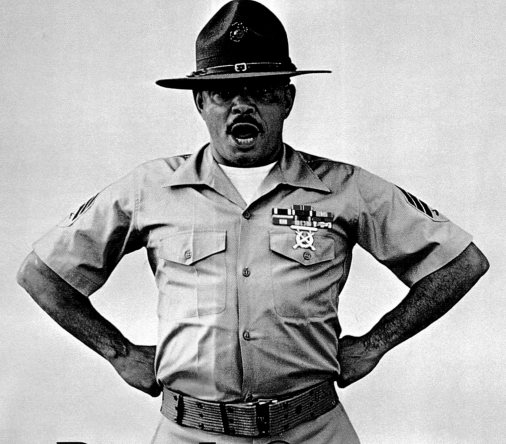

The Boys In Company C
MOVIE COMPANY
Columbia Pictures
DISTRIBUTOR OF FILM
Columbia Pictures
DESIGN FIRM
Mike Salisbury Communications Inc.
ART DIRECTOR
Mike Salisbury
DESIGNER
Mike Salisbury

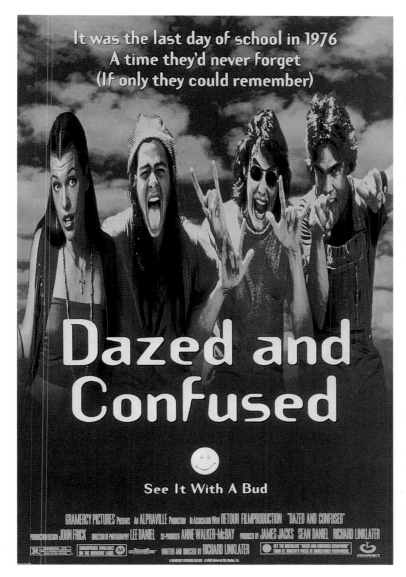

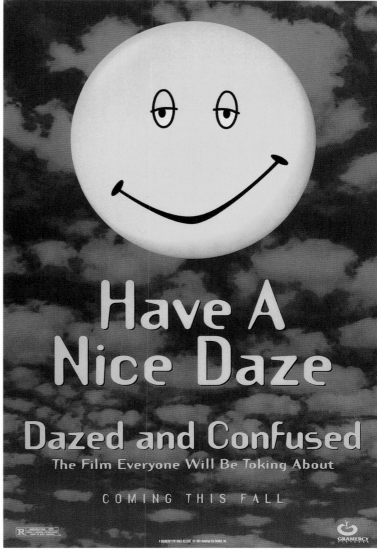

***Dazed and Confused,
poster***

MOVIE COMPANY

Universal Pictures

DISTRIBUTOR OF FILM

Gramercy Pictures

DESIGN FIRM/AGENCY

BRD Design

ART DIRECTORS

Tabitha Delatorre, Peter King
Robbins

DESIGNER

Peter King Robbins

Design was completed on Quantel
Paintbox®.

***Dazed and Confused,
teaser campaign***

MOVIE COMPANY

Universal Pictures

DISTRIBUTOR OF FILM

Gramercy Pictures

DESIGN FIRM/AGENCY

BRD Design

ART DIRECTORS

Samantha Hart, Peter King
Robbins

DESIGNER

Peter King Robbins

This image was developed with the
use of black and white print and
colorized photography. The happy
face was drawn on a Macintosh in
Aldus FreeHand.

Batman Returns

MOVIE COMPANY

Warner Bros.

DISTRIBUTOR OF FILM

Warner Bros.

DESIGN FIRM/AGENCY

The Idea Place

ART DIRECTOR

Maseeh Rafani

DESIGNERS

Jimmy Wachtel, Victor Martin

PHOTOGRAPHER

Jack Pedota

ILLUSTRATORS/ARTISTS

Myra Wood, Page Wood

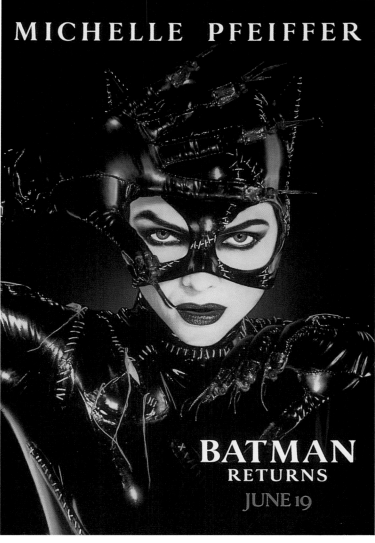

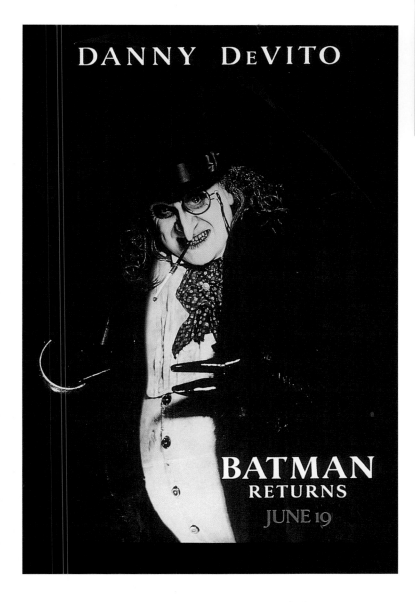

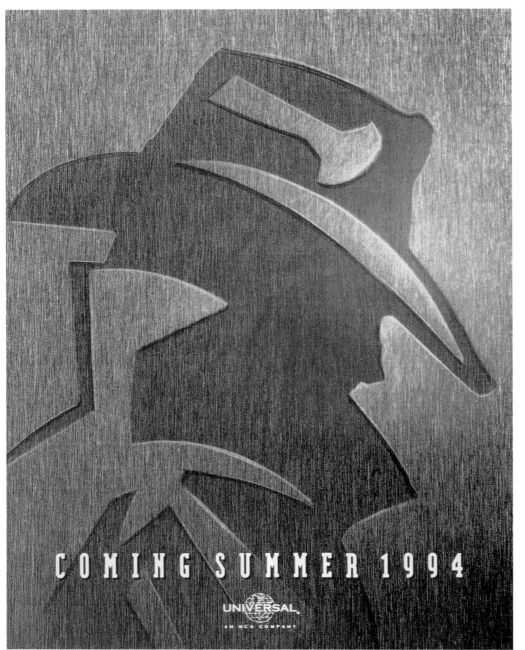

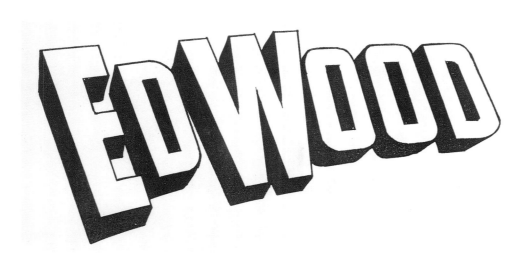

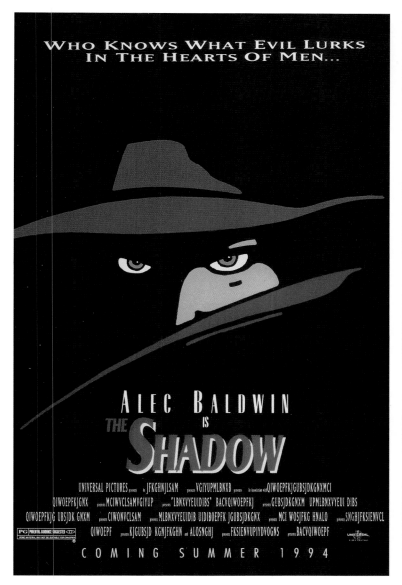

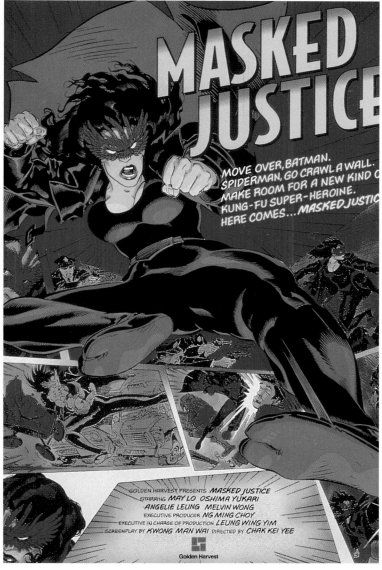

The Shadow

MOVIE COMPANY

Universal Pictures

DISTRIBUTOR OF FILM

Universal Pictures

DESIGN FIRM

Mike Salisbury Communications Inc.

ART DIRECTOR

Mike Salisbury

DESIGNER

Mike Salisbury

ILLUSTRATOR/ARTIST

Mike Schwab

The designers first used hand-drawn images, then reproduced them as rubdowns.

Masked Justice

MOVIE COMPANY

Golden Harvest

DISTRIBUTOR OF FILM

Golden Harvest

DESIGN FIRM

PPA Design Limited

ART DIRECTOR

Byron Jacobs

DESIGNER

Byron Jacobs

The text was hand-drawn, and the designers merged the illustration and text during color separation. The final color-separated film was offset printed.

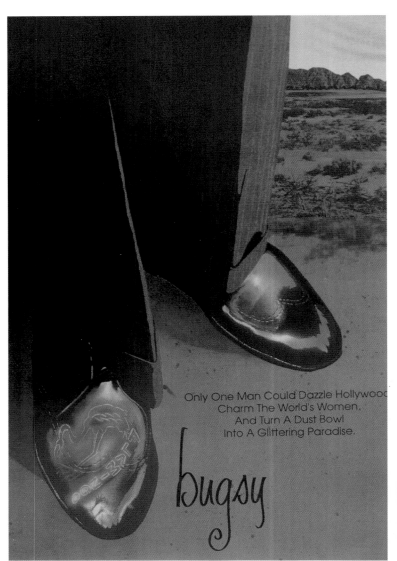

Only One Man Could Dazzle Hollywood
Charm The World's Women.
And Turn A Dust Bowl
Into A Glittering Paradise.

bugsy

Bugsy

MOVIE COMPANY

TriStar Pictures

DISTRIBUTOR OF FILM

TriStar Pictures

DESIGN FIRM

Mike Salisbury Communications Inc.

ART DIRECTOR

Mike Salisbury

DESIGNER

Mike Salisbury

ILLUSTRATORS/ARTISTS

Pam Hamilton, Pat Linse

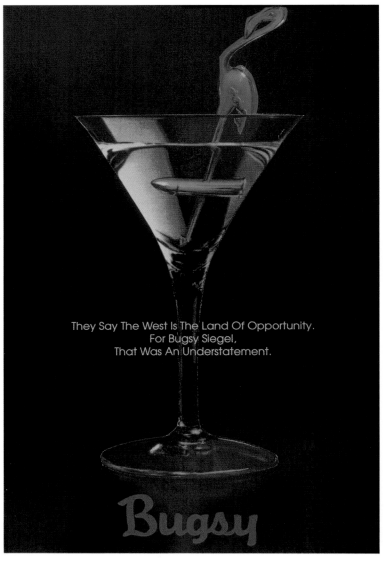

They Say The West Is The Land Of Opportunity.
For Bugsy Siegel,
That Was An Understatement.

Bugsy

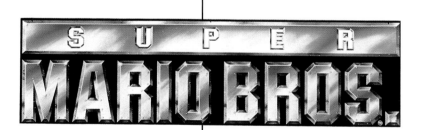

Super Mario Brothers
MOVIE COMPANY
Buena Vista Home Video, Inc.
DESIGN FIRM
The Dyment Company

This four-color image was mounted to foam board.

*Turner Entertainment Co.
Film Libraries*

MOVIE COMPANY

Turner Entertainment Co.

DISTRIBUTOR OF FILM

Turner Entertainment Co.

DESIGN FIRM

Tracy Sabin Graphic Design

ART DIRECTOR

Alison Hill

DESIGNER

Tracy Sabin

The layout was completed with the Art Expression structured drawing program on the Amiga platform. Storage and restoration of delicate film materials are an important function of the company, thus the atlas image.

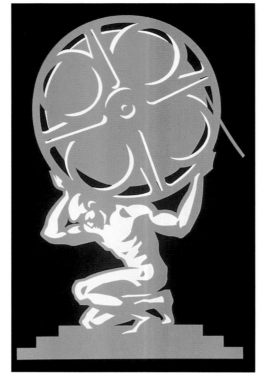

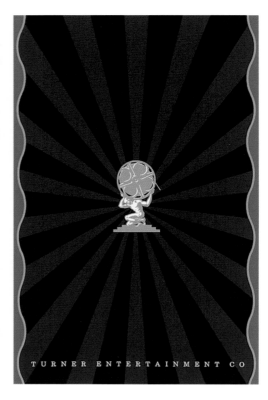

Star Tours-The Ride

MOVIE COMPANY

Disneyland

DESIGN FIRM

Mike Salisbury Communications Inc.

ART DIRECTOR

Mike Salisbury

DESIGNER

Dwight Smith

The logo for this Disneyland ride was hand-lettered.

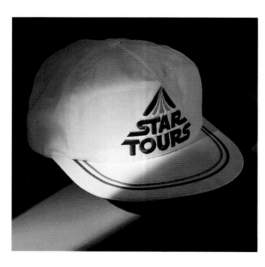

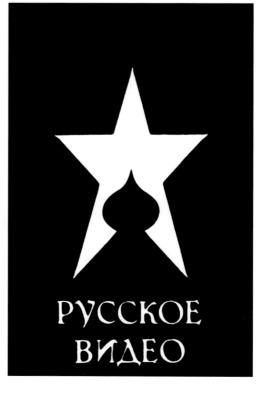

Logo

MOVIE COMPANY

Russian Video

DESIGN FIRM

Misha Design

ALL DESIGN

Michael Lenn

This company logo was hand-drawn.

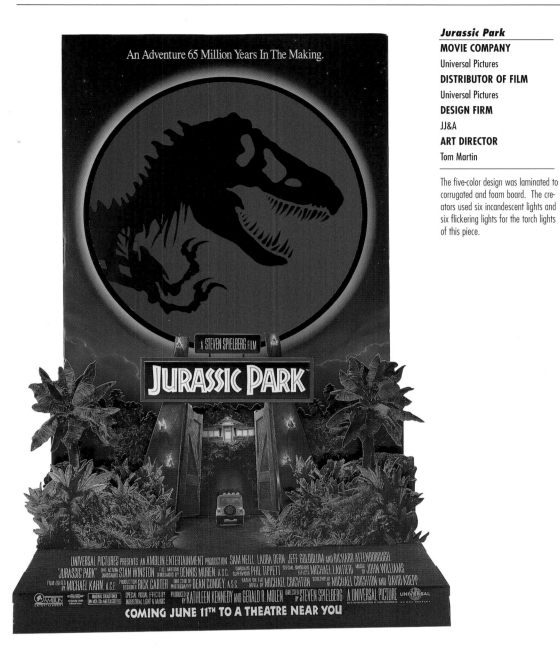

An Adventure 65 Million Years In The Making.

Jurassic Park

MOVIE COMPANY

Universal Pictures

DISTRIBUTOR OF FILM

Universal Pictures

DESIGN FIRM

JJ&A

ART DIRECTOR

Tom Martin

The five-color design was laminated to corrugated and foam board. The creators used six incandescent lights and six flickering lights for the torch lights of this piece.

Jurassic Park

MOVIE COMPANY

Universal Pictures

DISTRIBUTOR OF FILM

Universal Pictures

DESIGN FIRM

Mike Salisbury Communications Inc.

ART DIRECTOR

Tom Martin

DESIGNER

Mike Salisbury

The designer created these letters on Canon black and white copier. The letters were developed by stretching forms from an old hand lettering box.

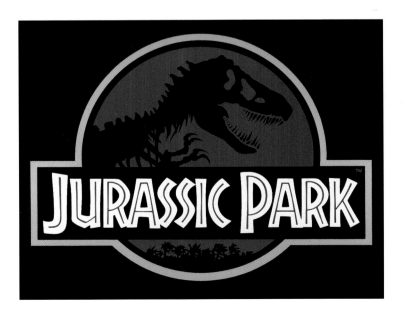

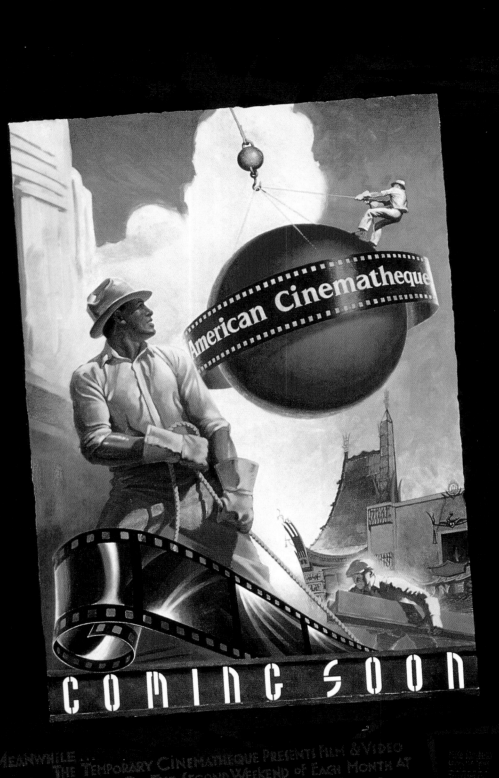

American Cinema Theque, poster

DESIGN FIRM
Mike Salisbury Communications Inc.

ART DIRECTOR
Mike Salisbury

DESIGNERS
Mike Salisbury, Terry Lamb

ILLUSTRATORS/ARTISTS
W.J. Vinson, Terry Land, Brian Sisson, Pat Linse

Designers used acrylic over canvas and hand-inked border for this graphic.

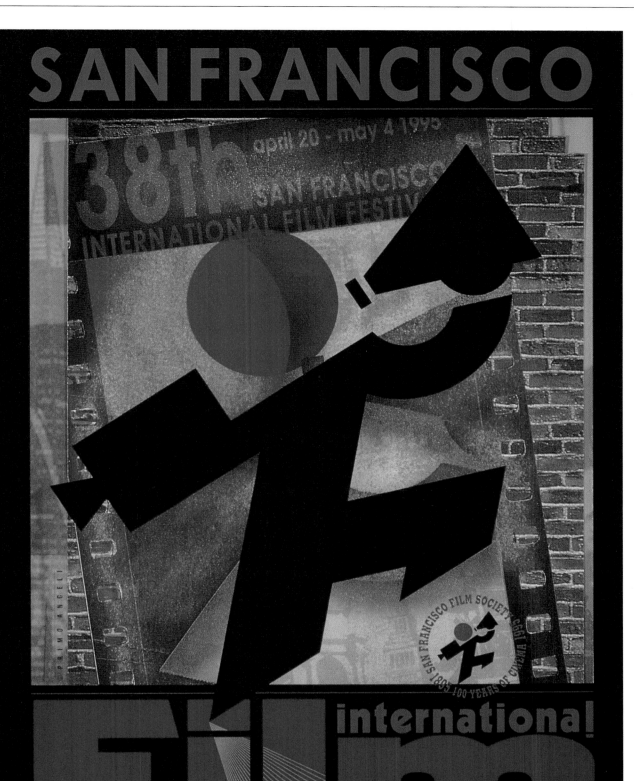

San Francisco International Film Festival Poster

MOVIE COMPANY

San Francisco Film Society

DESIGN FIRM

Primo Angeli Inc.

ART DIRECTORS

Carlo Pagoda, Primo Angeli

DESIGNER

Primo Angeli

ILLUSTRATORS/ARTISTS

Paul Terrill, Marcelo De Freitas

The poster was created using Adobe Illustrator. The textured look in the collage background was achieved through a unique application of WD-40 directly to the Cal-Comp print-out. The collage was then photographed and rescanned into the layout and the San Francisco Film Society trademark was superimposed at a diagonal.

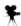

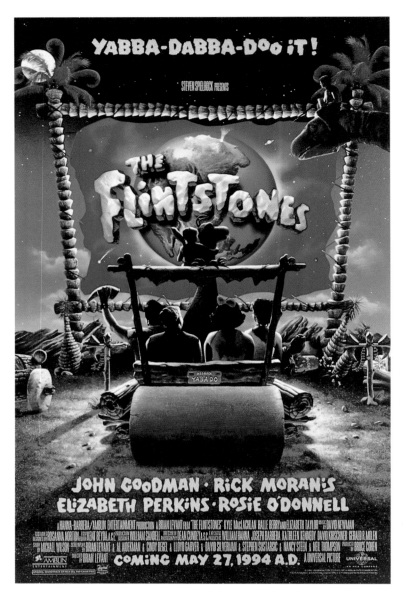

**The Flintstones,
teaser campaign**

MOVIE COMPANY

Amblin Entertainment

DISTRIBUTOR OF FILM

Universal Pictures

DESIGN FIRM

BLT & Associates Inc.

ART DIRECTOR

BLT & Associates Inc.

DESIGNER

BLT & Associates Inc.

DIGITAL IMAGING

Digital Transparency

ILLUSTRATOR/ARTIST

BLT/Mark Ryden

Designers for this teaser campaign
used a 6-color process.

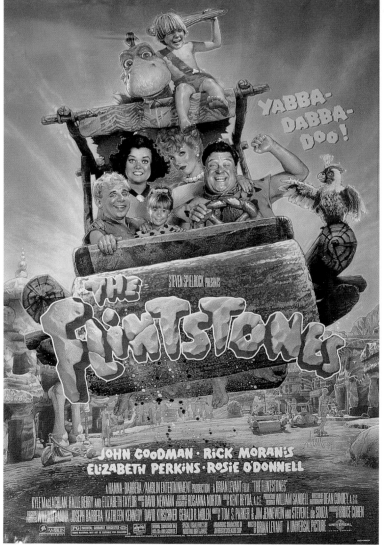

The Flintstones

MOVIE COMPANY

Amblin Entertainment

DISTRIBUTOR OF FILM

Universal Pictures

DESIGN FIRM

BLT & Associates Inc.

ART DIRECTOR

BLT & Associates Inc., Tom Martin

DESIGNER

BLT & Associates Inc.

PHOTOGRAPHER

George Lange

ILLUSTRATOR/ARTIST

BLT & Associates, Mark Ryden

A 6-color printing process was used
for this design.

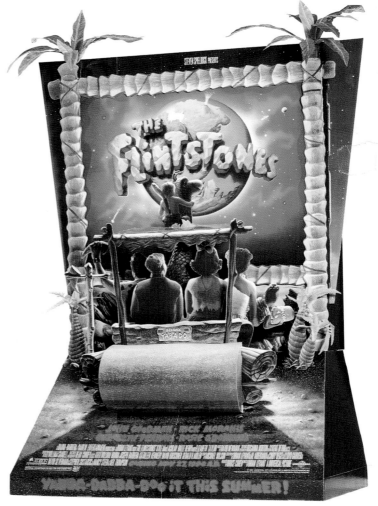

The Flintstones, mobile

MOVIE COMPANY

Amblin Entertainment

DISTRIBUTOR OF FILM

Universal Pictures

DESIGN FIRM

JJ&A

ART DIRECTOR

Tom Martin

ILLUSTRATOR/ARTIST

Drew Struzan

This five-color mobile was laminated to foam board.

The Flintstones, standee

MOVIE COMPANY

Amblin Entertainment

DISTRIBUTOR OF FILM

Universal Pictures

DESIGN FIRM/AGENCY

BLT & Associates Inc.

ART DIRECTOR

BLT & Associates Inc., Tom Martin

DESIGNER

BLT & Associates Inc.

DIGITAL IMAGING & DIGITAL TRANSPARENCY,

BLT & Associates

ILLUSTRATOR/ARTIST

BLT & Associates, Mark Ryden

The designers of this standee used a combination of illustration and digital imaging in this six-color image.

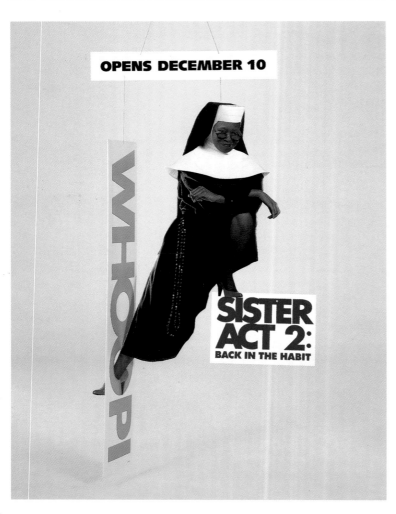

OPENS DECEMBER 10

WHOOPI

SISTER ACT 2: BACK IN THE HABIT

Sister Act 2, mobile

MOVIE COMPANY

The Walt Disney Company

DISTRIBUTOR OF FILM

The Walt Disney Company

DESIGN FIRM

JJ&A

ART DIRECTOR

Fred Tio

DESIGNER

JJ&A

The designers created a mobile with a four-color image laminated to foam board.

Naked Gun 33 1/3, standee

MOVIE COMPANY

Paramount Pictures

DESIGN FIRM

5555 Communications

ART DIRECTOR

Scott Dobson

DESIGNER

Scott Dobson

PHOTOGRAPHERS

Kevin Stapleton, Ron Phillips

LOGO ARTISTS

Scott Dobson, Kevin Bachman

On this four-color image designers employed huge sheet-fed presses for printing, along with a silk-screening process for the background.

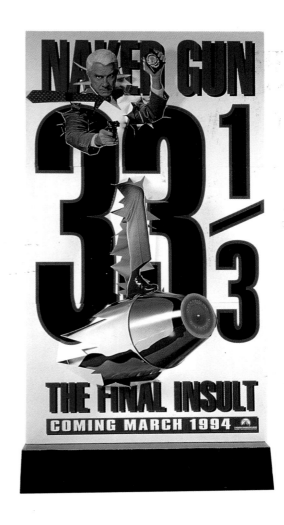

NAKED GUN 33 1/3

THE FINAL INSULT
COMING MARCH 1994

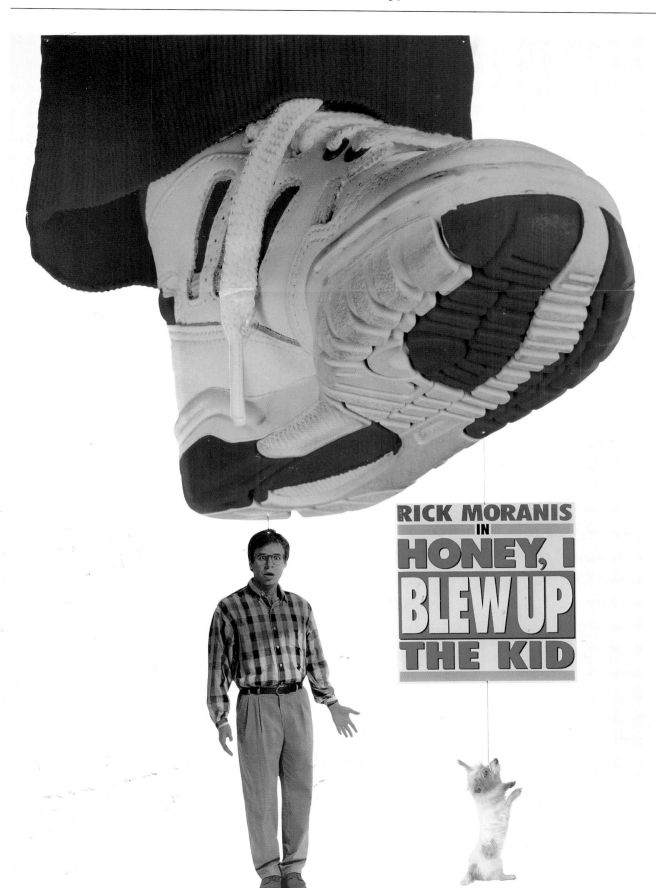

Honey I Blew Up the Kid,
mobile

MOVIE COMPANY

The Walt Disney Company

DISTRIBUTOR OF FILM

The Walt Disney Company

DESIGN FIRM

JJ&A

ART DIRECTOR

Linda Morales

DESIGNER

JJ&A

This four-color mobile was laminated to
foam board.

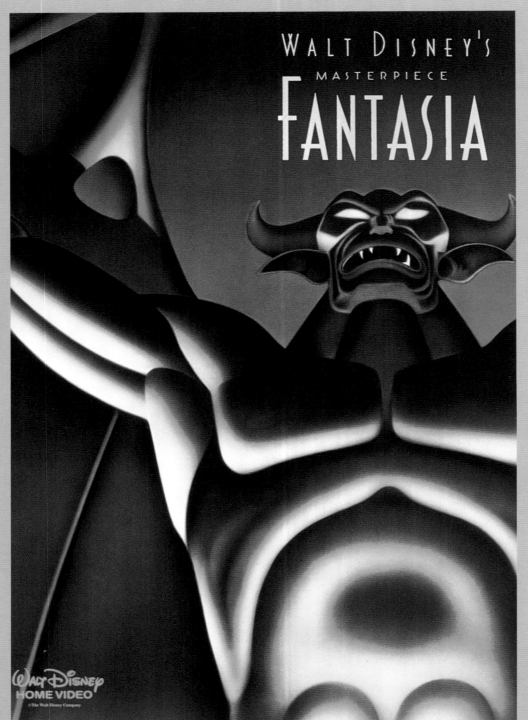

Fantasia

MOVIE COMPANY

Buena Vista Home Video

DESIGN FIRM

30sixty design, Inc.

ART DIRECTOR

Henry Vizcarra

DESIGNER

Glenn Sweitzer

PHOTOGRAPHER

Michael Bryant

LOGO ARTIST

Andy Engel

Fantasia

MOVIE COMPANY

Buena Vista Home Video

DESIGN FIRM

30sixty design, Inc.

ART DIRECTOR

Henry Vizcarra

DESIGNER

Glenn Sweitzer

PHOTOGRAPHER

Michael Bryant

LOGO ARTIST

Andy Engel

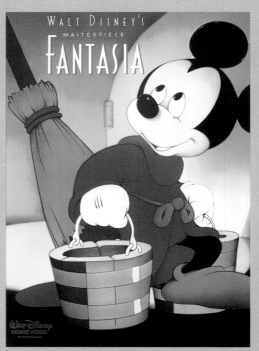

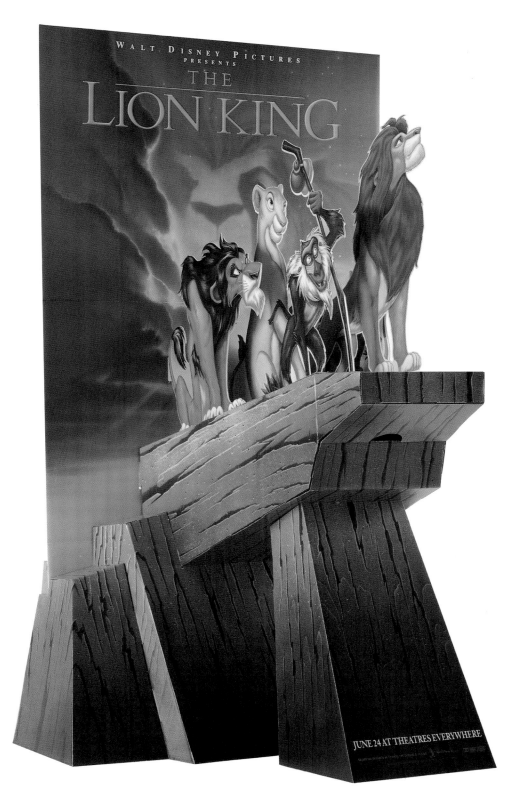

The Lion King, standee

MOVIE COMPANY

The Walt Disney Company

DISTRIBUTOR OF FILM

The Walt Disney Company

DESIGN FIRM

JJ&A

ART DIRECTOR

Fred Tio

DESIGNER

John Kwan

ILLUSTRATOR/ARTIST

Dave Willardson

Corrugated board and foam board
were used for this four-color standee.

The Lion King

MOVIE COMPANY

The Walt Disney Company

DESIGN FIRM

JJ&A

ART DIRECTOR

Fred Tio

DESIGNER

John Kwan

ILLUSTRATOR/ARTIST

Dave Willardson

The designers laminated this four-
color image to foam board.

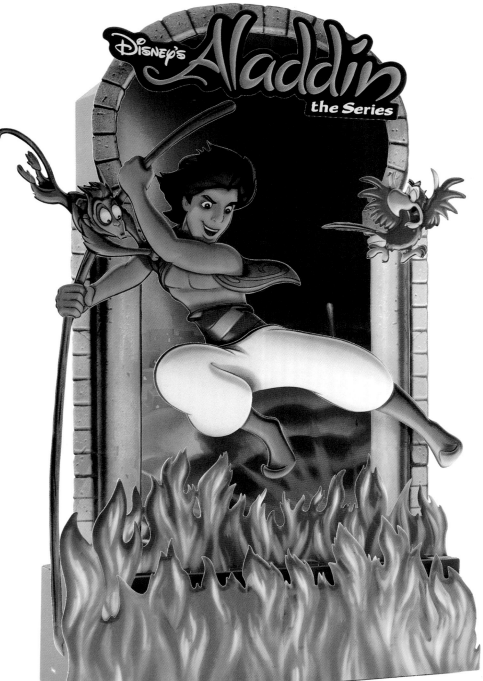

Aladdin, The Series

MOVIE COMPANY

The Walt Disney Company

DISTRIBUTOR OF FILM

Buena Vista Television

DESIGN FIRM

JJ&A

ART DIRECTOR

Jimmy Lee

DESIGNER

Jimmy Lee

After laminating this four-color image to both corrugated board and foam board, the designers used incandescent lights to illuminate the design.

Aladdin, mobile

MOVIE COMPANY

The Walt Disney Company

DISTRIBUTOR OF FILM

The Walt Disney Company

DESIGN FIRM

JJ&A

ART DIRECTOR

Linda Morales

DESIGNER

JJ&A

ILLUSTRATOR/ARTIST

David Willardson

The creators laminated this four-color mobile to foam board.

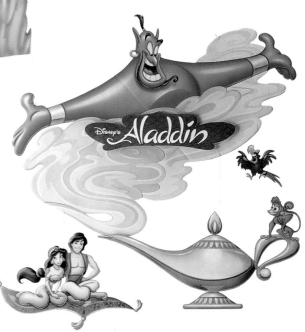

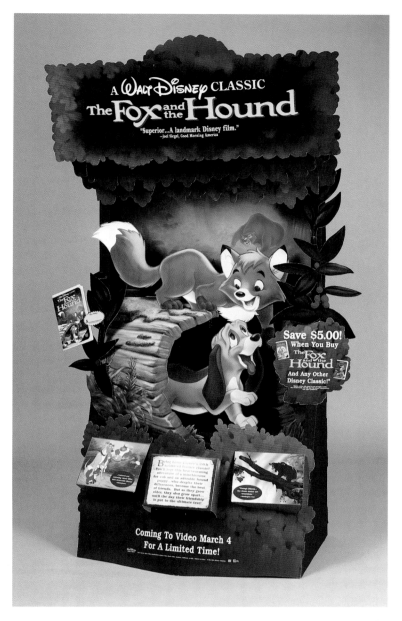

The Fox and the Hound

MOVIE COMPANY

Buena Vista Home Video, Inc.

DESIGN FIRM

The Dyment Company

ART DIRECTOR

Jackson Dillard

DESIGNER

John Strejan

The creators chose a 4-color printing process on the tag stock in combination with 4-color process sheets mounted on corrugated cardboard.

Aladdin

MOVIE COMPANY

Buena Vista Home Video, Inc.

DESIGN FIRM

The Dyment Company

ART DIRECTOR

Jackson Dillard

DESIGNER

John Strejan

The designers mounted this four-color image on foam board.

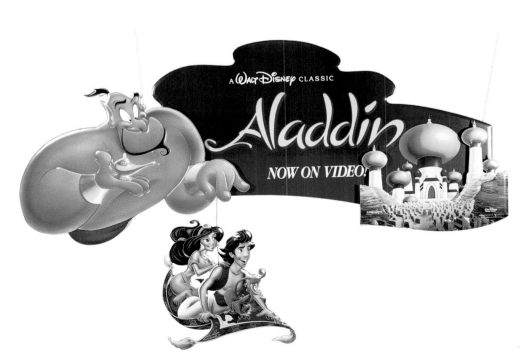

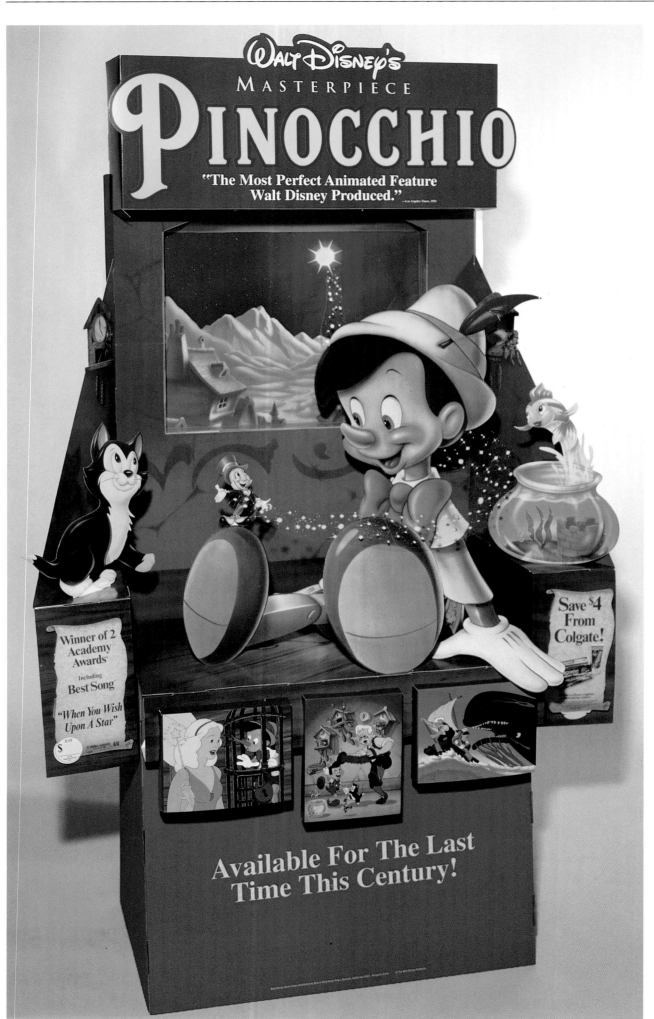

Pinocchio

MOVIE COMPANY
Buena Vista Home Video, Inc.

DESIGN FIRM
The Dyment Company

ART DIRECTOR
Jackson Dillard

DESIGNER
John Strejan

The designers employed a 4-color printing process on both tag stock and on sheets mounted to corrugated cardboard.

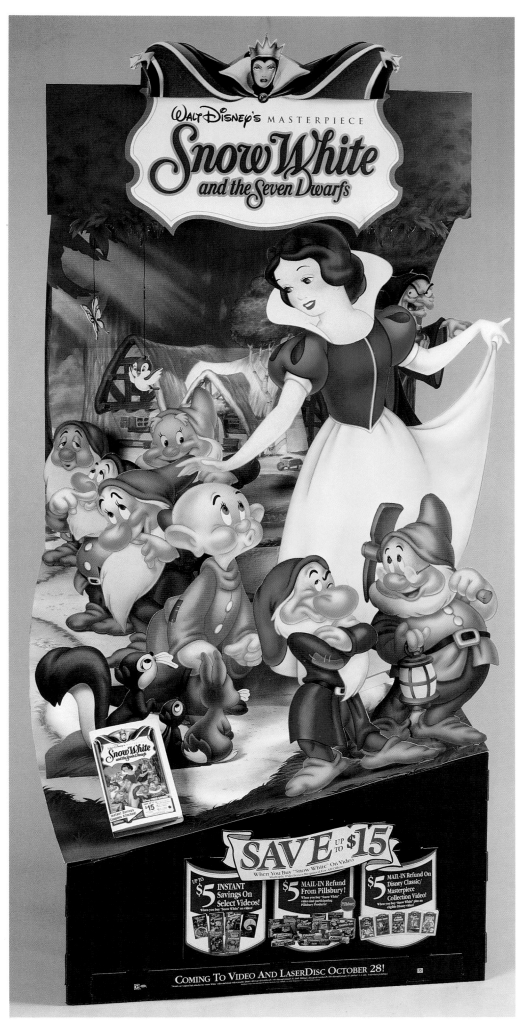

Snow White and the Seven Dwarfs

MOVIE COMPANY

Buena Vista Home Video, Inc.

DESIGN FIRM

The Dyment Company

ART DIRECTOR

Jackson Dillard

DESIGNER

John Strejan

Designers created this four-color piece on tag board and then mounted it to corrugated cardboard.

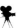

**The Cowboy Way,
standee**

MOVIE COMPANY
Universal Pictures

DISTRIBUTOR OF FILM
Universal Pictures

DESIGN FIRM
JJ&A

ART DIRECTOR
Tom Martin

Designers used a 4-color printing
process to create this image and then
laminated it onto both corrugated
board and foam board.

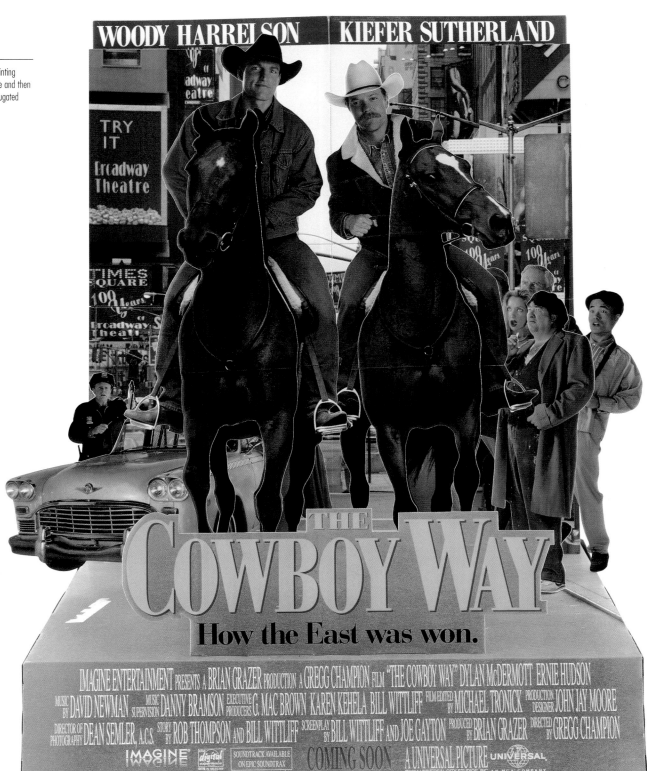

Old Gringo, standee
MOVIE COMPANY
Columbia Pictures
DISTRIBUTOR OF FILM
Columbia Pictures
DESIGN FIRM
Mike Salisbury Communications Inc.
ART DIRECTOR
Mike Salisbury
DESIGNER
Mike Salisbury

Designers used a combination of photo-composition, hand-lettering, and airbrush effects.

MOVIE COMPANY
Columbia Pictures
DISTRIBUTOR OF FILM
Columbia Pictures
DESIGN FIRM
Frankfurt Balkind Partners
ART DIRECTOR
Kim Wexman
DESIGNER
Kim Wexman
PHOTOGRAPHER
Michael O'Neil
CREATIVE DIRECTOR
Peter Bemis
COPYWRITER
Ari Sherman

Designers used a Polaroid image, a tight crop, and computer effects, including grain and color tools, for this design. The eye was shifted yellow, and tension was created in the image because the lips were lined up.

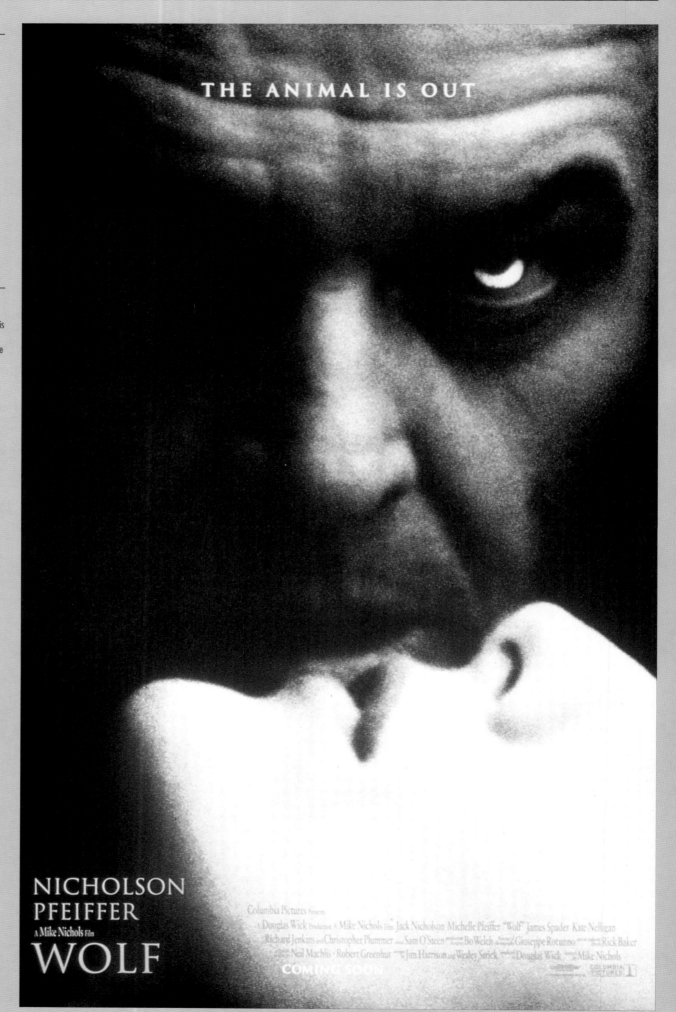

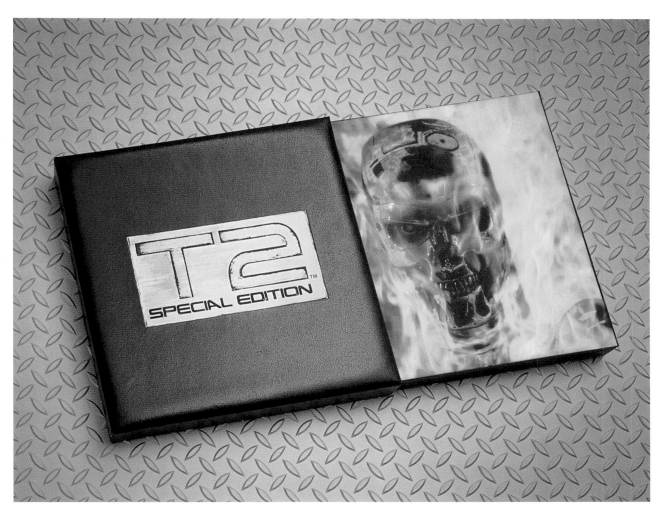

Terminator 2

MOVIE COMPANY

Pioneer LDCA, Inc.

DESIGN FIRM

30sixty design, Inc.

ART DIRECTOR

Henry Vizcarra

DESIGNER

Vu Tran

This design is for a special edition laser disc package.

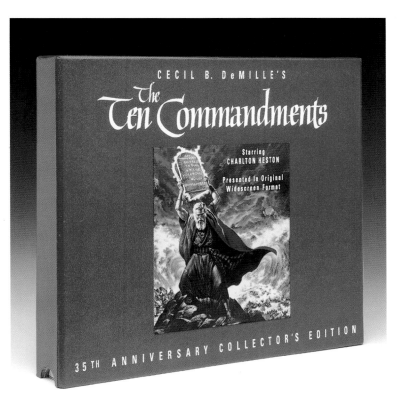

The Ten Commandments

MOVIE COMPANY

Paramount Home Video

DESIGN FIRM

30sixty design, Inc.

ART DIRECTOR

Henry Vizcarra

DESIGNER

Vu Tran

The creators made this especially for the 35th Anniversary Collector's Edition on videocassette.

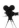

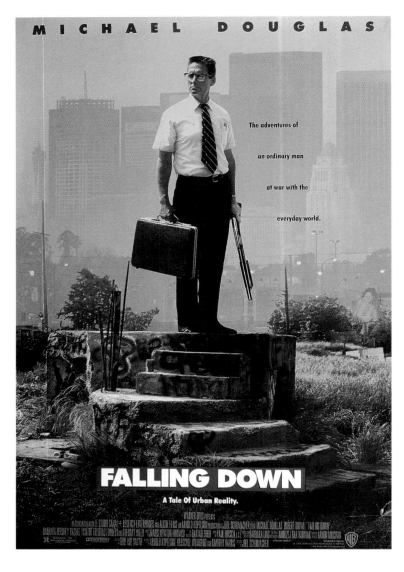

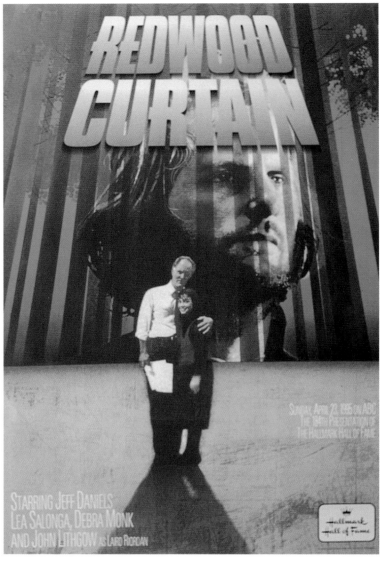

Falling Down

MOVIE COMPANY

TriStar Pictures

DISTRIBUTOR OF FILM

TriStar Pictures

DESIGN FIRM

BLT & Associates Inc.

ART DIRECTOR

BLT & Associates Inc.

DESIGNER

BLT & Associates Inc.

PHOTOGRAPHERS

Peter Surval, Arnold Kopelson

DIGITAL IMAGING

Imagic

The designers used a 4-color printing
process on this image.

Redwood Curtain

DISTRIBUTOR OF FILM

Chris/Rose Production, Inc. in
association with Hallmark Hall of
Fame Prod. Inc.

DESIGN FIRM

Muller + Company

ART DIRECTOR

John Muller

DESIGNER

Scott Chapman

ILLUSTRATOR/ARTIST

Mark English

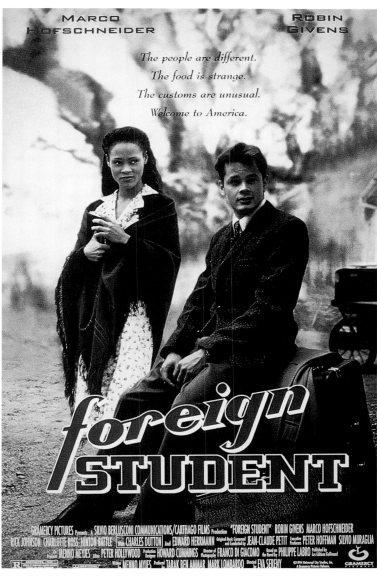

Final Conflict, poster

MOVIE COMPANY

Twentieth Century Fox

DISTRIBUTOR OF FILM

Twentieth Century Fox

DESIGN FIRM

Mike Salisbury Communications Inc.

ART DIRECTOR

Mike Salisbury

DESIGNER

Jack Wood

The photograph of fire was stripped into the photo of the actor and the photo of the presidential seal.

Foreign Student

MOVIE COMPANY

Universal Pictures

DISTRIBUTOR OF FILM

Gramercy Pictures

DESIGN FIRM

BRD Design

ART DIRECTOR

Neville Burtis

DESIGNER

Neville Burtis

Imagery was composited in Quantel Paintbox® from unit photography.

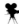

Orlando

MOVIE COMPANY
Columbia TriStar Home Video
DISTRIBUTOR OF FILM
Columbia TriStar Home Video
DESIGN FIRM
Dawn Patrol
ART DIRECTOR
Jimmy Wachtel
DESIGNERS
Jimmy Wachtel, Victor Martin
LOGO
Peter Greco
ILLUSTRATOR/ARTIST
Cronopious

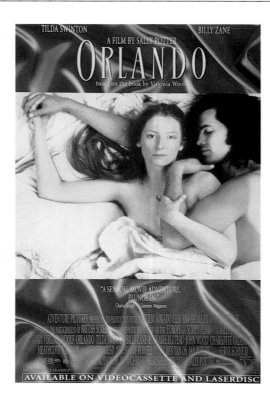

Gas, Food & Lodging

MOVIE COMPANY
Columbia TriStar Home Video
DESIGN FIRM
Dawn Patrol
ART DIRECTOR
Jimmy Wachtel
DESIGNERS
Jimmy Wachtel, Victor Martin
PHOTOGRAPHER
Diego Uchitel
ILLUSTRATOR/ARTIST
Myra Wood
COPY WRITER
Frederica Cooper
LOGO ARTISTS
Jim Fitipaldi, Peter Greco

Sh'Chur

MOVIE COMPANY
Moviez Entertainment
DISTRIBUTOR OF FILM
Erez Films
DESIGN FIRM
Yesh!
ART DIRECTOR
Yehudith Schatz
DESIGNER
Yehudith Schatz
PHOTOGRAPHERS
Jacky Matitiahu,
Yoni Hamenachem
ILLUSTRATOR/ARTIST
Yehudith Schatz

Stills from the film were scanned into a computer and altered in Aldus Freehand and Adobe Photoshop on a Macintosh Quadra 650. Stills were arranged so that they represent sequences from the film, without manipulation techniques, and the logo design was performed on the "feather" channel in Adobe Photoshop.

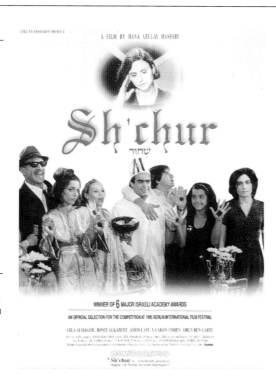

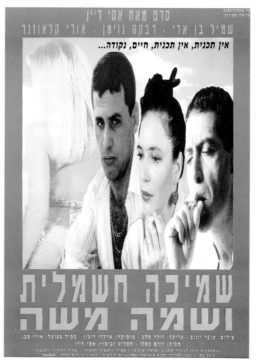

Electric Blanket

MOVIE COMPANY
Moviez Entertainment
DISTRIBUTOR OF FILM
Erez Films
DESIGN FIRM
Yesh!
ART DIRECTOR
Yehudith Schatz
DESIGNER
Yehudith Schatz
PHOTOGRAPHER
Eitan Shukeri
ILLUSTRATOR/ARTIST
Yehudith Schatz

Stills from the film were scanned into a computer and manipulated in Aldus Freehand and Adobe Photoshop on a Macintosh Quadra 650. The designers narrowed the foreground stills montage of the three leading actors in order to emphasize the surreal feeling of the film. The background was created with brightened stills of a sky and a billboard.

Equinox

MOVIE COMPANY
Columbia TriStar Home Video

DISTRIBUTOR OF FILM
IRS

DESIGN FIRM
Dawn Patrol

ART DIRECTOR
Jimmy Wachtel

DESIGNERS
Victor Martin, Jimmy Wachtel

LOGO ARTIST
Mercy Azarron

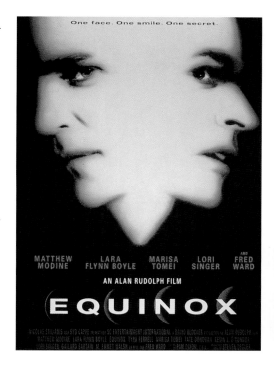

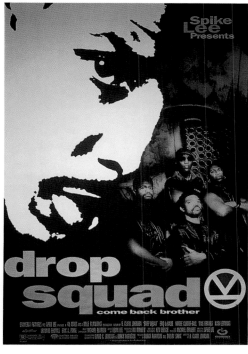

Drop Squad

MOVIE COMPANY
Gramercy Pictures

DISTRIBUTOR OF FILM
Gramercy Pictures

DESIGN FIRM
BRD Design

ART DIRECTOR
Peter Robbins

DESIGNERS
Anne Kelly, Peter Robbins

This image from the film was heavily retouched in Adobe Photoshop. The final design was printed 4-color.

Red Rock West

MOVIE COMPANY
Columbia TriStar Home Video

DISTRIBUTOR OF FILM
Showtime

DESIGN FIRM
Dawn Patrol

ART DIRECTOR
Jimmy Wachtel

DESIGNER
Victor Martin

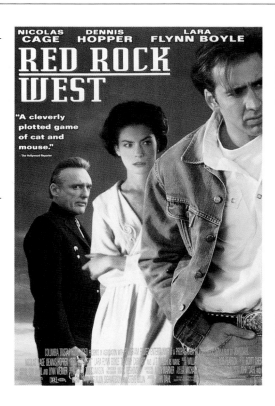

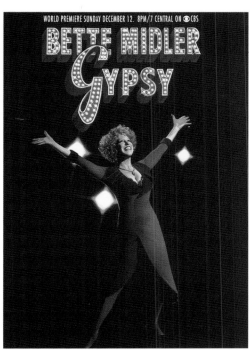

Gypsy

MOVIE COMPANY
Storyline Productions

DISTRIBUTOR OF FILM
CBS

AGENCY
B.D. Fox & Friends, Inc.
Advertising

ART DIRECTORS
Mitch Strausberg, Brian D. Fox

DESIGNER
Mitch Strausberg

PHOTOGRAPHER
Greg Gorman

LOGO ARTIST
Chris Dellorco

While this design was kept simple, designers employed a lot of computer cosmetic retouching.

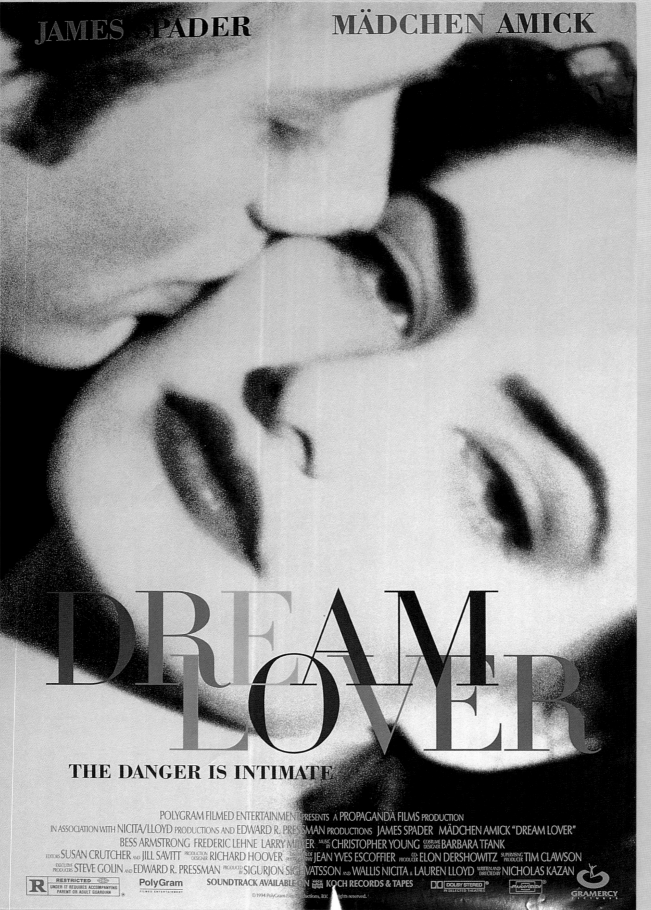

Dream Lover
MOVIE COMPANY
Polygram Filmed Entertainment
DISTRIBUTOR OF FILM
Gramercy Pictures
DESIGN FIRM
Gramercy Pictures
ART DIRECTOR
Samantha Hart
DESIGNER
Eric Roinestad
PHOTOGRAPHER
Michael Childers

Six colors were used for this image.

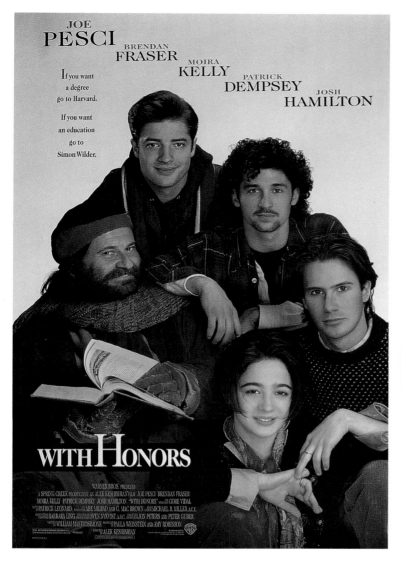

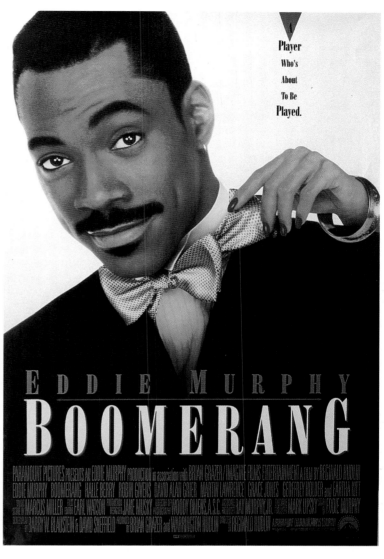

With Honors

MOVIE COMPANY

Warner Bros.

DISTRIBUTOR OF FILM

Warner Bros.

DESIGN FIRM

BLT & Associates Inc.

ART DIRECTOR

BLT & Associates Inc.

DESIGNER

BLT & Associates Inc.

PHOTOGRAPHER

Timothy White

DIGITAL IMAGING

Digital Transparency

A four-color printing process was
used for this design.

Boomerang

MOVIE COMPANY

Paramount Pictures

DISTRIBUTOR OF FILM

Paramount Pictures

DESIGN FIRM

BLT & Associates Inc.

ART DIRECTOR

BLT & Associates Inc.

DESIGNER

BLT & Associates Inc.

PHOTOGRAPHER

Herb Ritts

DIGITAL IMAGING

Electric Paint

The design for this graphic was
developed with a 6-color printing
process.

Réve Aveugle

MOVIE COMPANY
Canadian National Film Board
ILLUSTRATOR/ARTIST
James Bentley

This design was first hand-drawn, then a layer of gouache was put on the whole surface with a brush. When dry, highlights were made using an electric eraser along with additional touch-ups completed with Prismacolor and a fine paint brush.

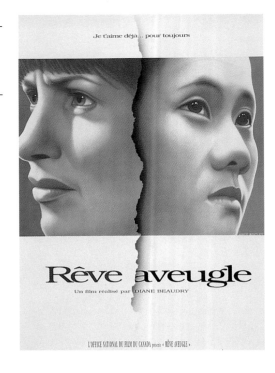

The Boy Who Could Fly

MOVIE COMPANY
Lorimar
DISTRIBUTOR OF FILM
Lorimar
DESIGN FIRM
Mike Salisbury Communications Inc.
ART DIRECTOR
Mike Salisbury
DESIGNER
Mike Salisbury
ILLUSTRATOR/ARTIST
Jeff Wack

For this design, artists airbrushed the background and printed the photography high-key.

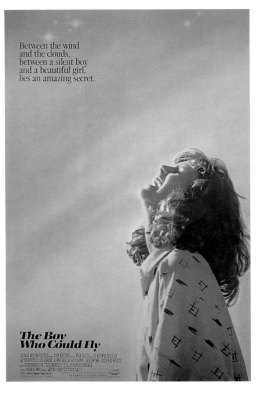

A Dangerous Woman

MOVIE COMPANY
Universal Pictures
DISTRIBUTOR OF FILM
Gramercy Pictures
DESIGN FIRM
BRD Design
ART DIRECTORS
Peter King Robbins, Neville Burtis
DESIGNER
Peter King Robbins

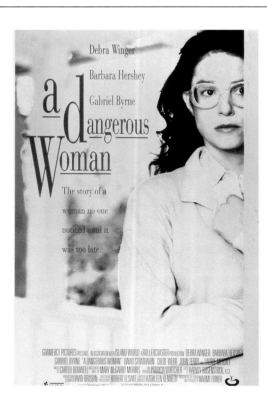

Nobody's Fool

MOVIE COMPANY
Paramount Pictures
DISTRIBUTOR OF FILM
Paramount Pictures
DESIGN FIRM
BLT & Associates Inc.
ART DIRECTOR
BLT & Associates Inc.
DESIGNER
BLT & Associates Inc.
PHOTOGRAPHER
Elliott Erwitt
DIGITAL IMAGING
BLT & Associates Inc.

This design was printed using a 4-color printing process.

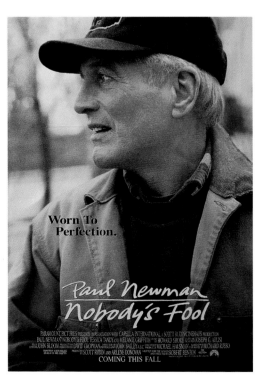

Tollbooth

MOVIE COMPANY
Trans Atlantic Entertainment

DISTRIBUTOR OF FILM
Trans Atlantic Entertainment

DESIGN FIRM
BRD Design

ART DIRECTOR
Neville Burtis

DESIGNER
Neville Burtis

Imagery was a result of a special photo shoot. Designers chose a 4-color printing process.

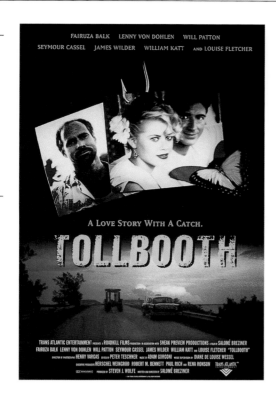

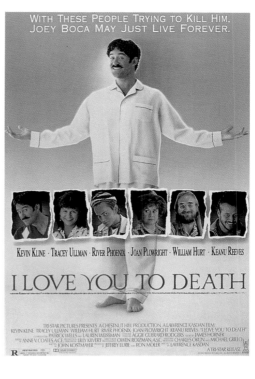

I Love You to Death, poster

MOVIE COMPANY
TriStar Pictures

DISTRIBUTOR OF FILM
TriStar Pictures

DESIGN FIRM
Mike Salisbury Communications Inc.

ART DIRECTOR
Mike Salisbury

DESIGNER
Mike Salisbury

Dye transfers for this graphic were retouched by hand.

Return to the Blue Lagoon

MOVIE COMPANY
TriStar Pictures

DISTRIBUTOR OF FILM
TriStar Pictures

DESIGN FIRM
Mike Salisbury Communications Inc.

ART DIRECTOR
Mike Salisbury

DESIGNER
Mike Salisbury

ILLUSTRATORS/ARTISTS
Jeff Wack, Jack Upston, Pat Linse, Pam Hamilton

The photos were shot to match a sketch, and the background was created with a stock photo of an island. The images were airbrushed.

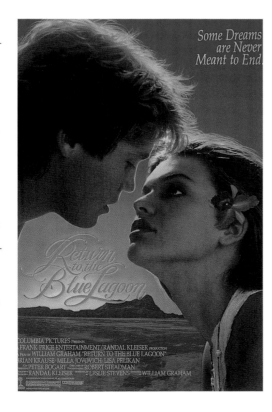

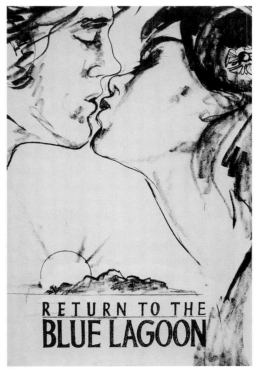

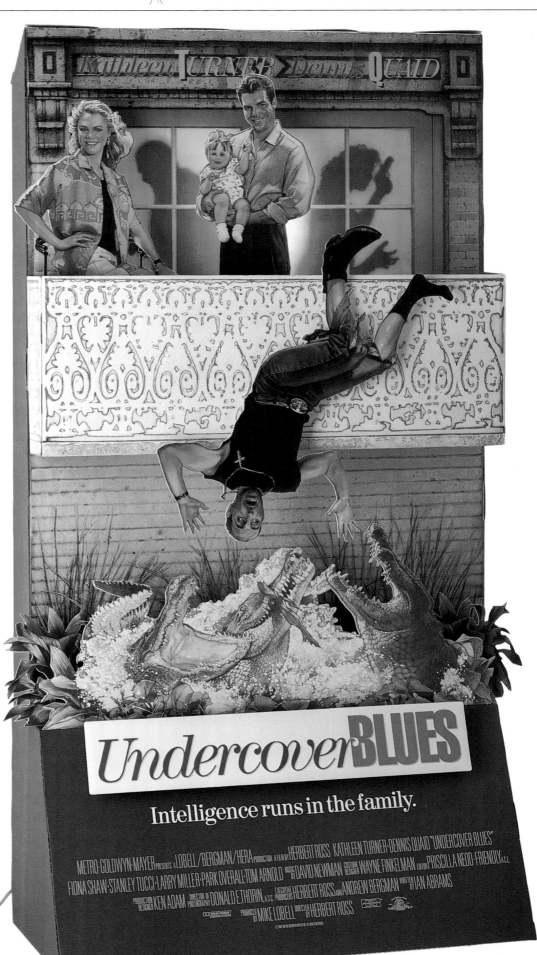

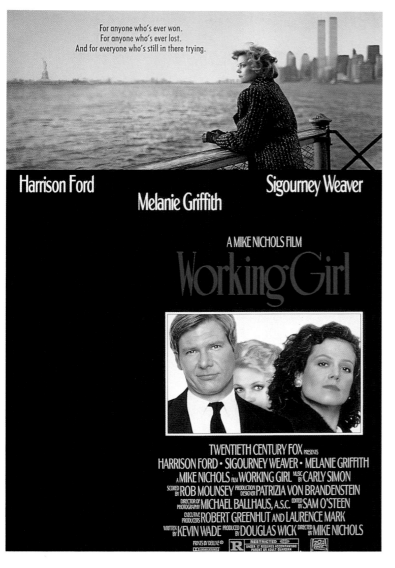

Working Girl, poster

MOVIE COMPANY

Twentieth Century Fox

DISTRIBUTOR OF FILM

Twentieth Century Fox

DESIGN FIRM

Mike Salisbury Communications Inc.

ART DIRECTOR

Chris Pula

DESIGNERS

Mike Salisbury, Mike Nichols, Terry Lamb, Brian Fox

Designers widened the photograph of Melanie Griffith and added the image of the Statue of Liberty and the boat railing in the computer.

Bury Me High

MOVIE COMPANY

Golden Harvest

DISTRIBUTOR OF FILM

Golden Harvest

DESIGN FIRM

PPA Design Limited

ART DIRECTOR

Byron Jacobs

DESIGNER

Nick Rhodes

The typography and artwork was created in Aldus Freehand then scanned in and illustrated on Quantel Paintbox®. All materials were printed offset, and the title art was applied to lobby cards and posters.

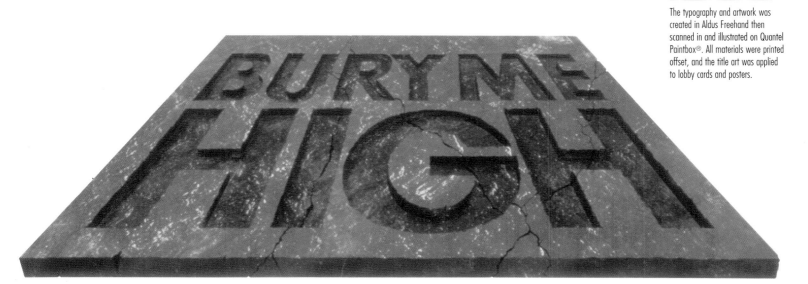

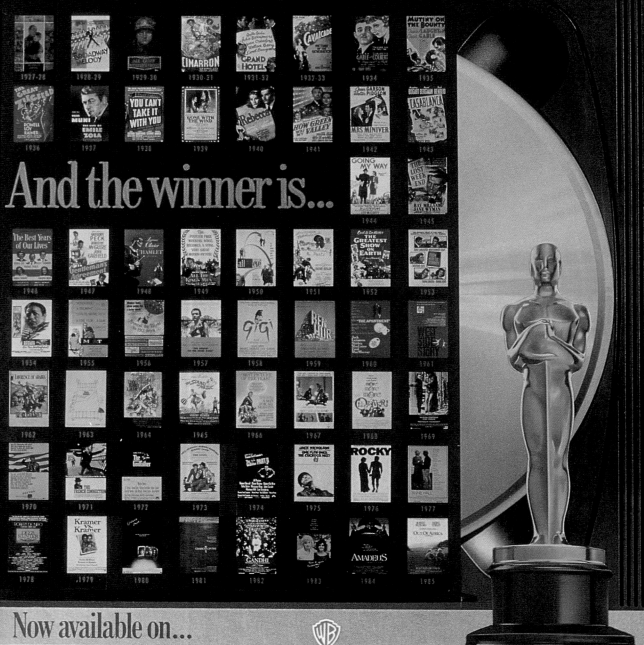

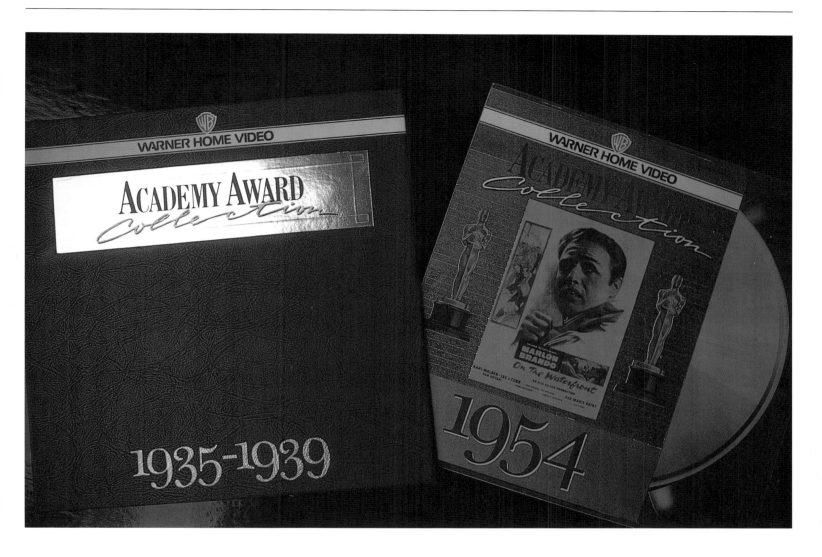

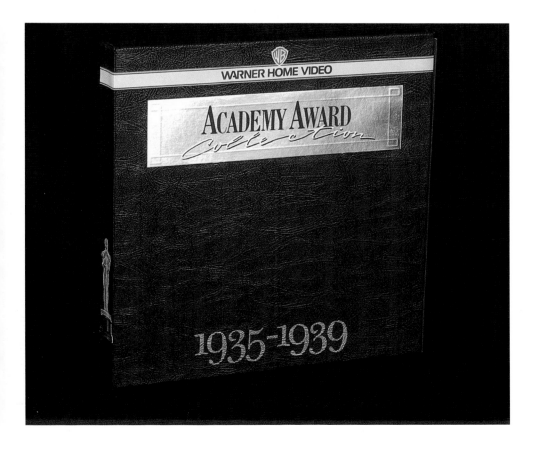

**Academy Awards,
video packaging**
DESIGN FIRM
Mike Salisbury Communications Inc.
ART DIRECTOR
Mike Salisbury
DESIGNERS
Mike Salisbury, Dwight Smith

Design was created with the use of
photo-realistic leather with gold
embossing.

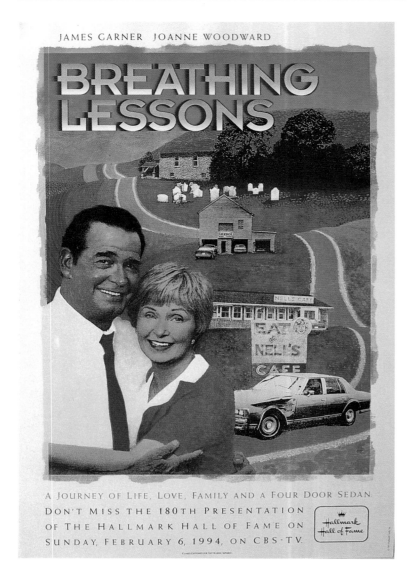

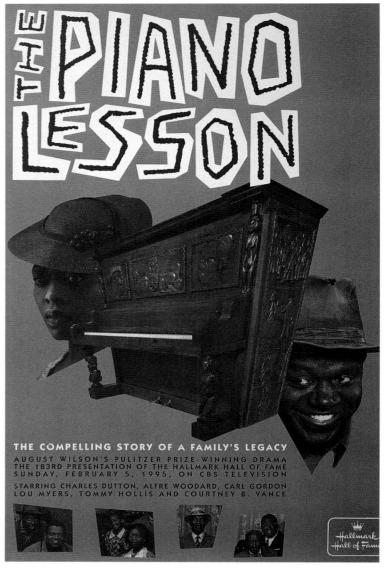

Breathing Lessons

DISTRIBUTOR OF FILM

A Self Productions, Inc. & Trillium
Productions, Inc. production

DESIGN FIRM

Muller + Company

ART DIRECTOR

John Muller

DESIGNER

Scott Chapman

ILLUSTRATOR/ARTIST

Mark English

The designers scanned conventional
illustration, and the logo treatment
was assembled on Sci-tex.

The Piano Lesson

DISTRIBUTOR OF FILM

Hallmark Hall Of Fame
Productions, Inc.

DESIGN FIRM

Muller + Company

ART DIRECTOR

John Muller

DESIGNER

Scott Chapman

PHOTOGRAPHERS

Hallmark staff

Hand-drawn squiggles were added to
the existing logo by the designers.
The photos were scanned low-resolu-
tion and manipulated in Adobe
Photoshop. The final image was
assembled by the printer on Sci-tex.

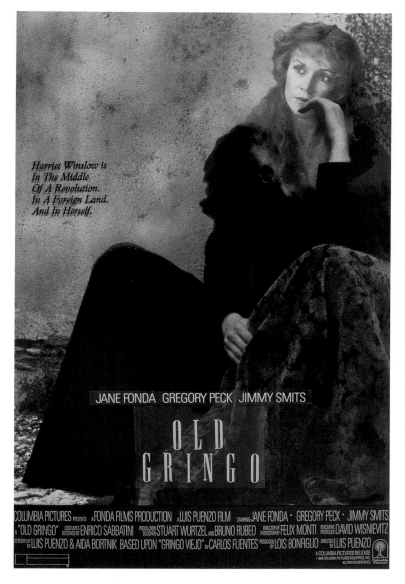

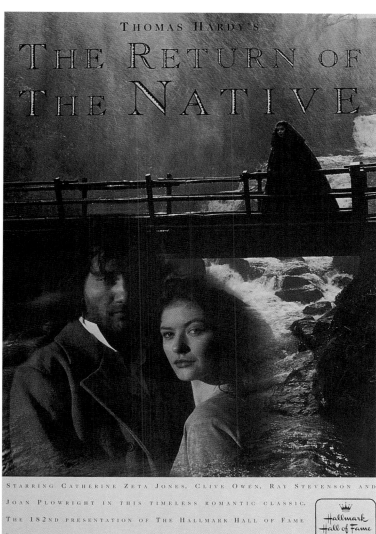

Old Gringo, standee

MOVIE COMPANY

Columbia Pictures

DISTRIBUTOR OF FILM

Columbia Pictures

DESIGN FIRM

Mike Salisbury Communications Inc.

ART DIRECTOR

Mike Salisbury

DESIGNER

Mike Salisbury

Designers used a combination of
photo-composition, hand-lettering,
and airbrush effects.

Return of the Native

DISTRIBUTOR OF FILM

A Self Productions, Inc. & Trillium
Productions, Inc. production

DESIGN FIRM

Muller + Company

ART DIRECTOR

John Muller

DESIGNER

Scott Chapman

PHOTOGRAPHERS

Hallmark staff

Photos were scanned low-resolution
and assembled in Adobe Photoshop.
A transparency was assembled by a
retoucher following original low-reso-
lution specs. The printing was offset.

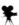

King of the Hill

MOVIE COMPANY
Gramercy Pictures
DESIGN FIRM
Frankfurt Balkind Partners
ART DIRECTOR
Kim Wexman
DESIGNER
Kim Wexman
PHOTOGRAPHER
David Lee
CREATIVE DIRECTOR
Peter Bemis
COPYWRITER
Ari Sherman

The little photo was manipulated to have warmer tones. Designers used both a large amount of white space and clean typography.

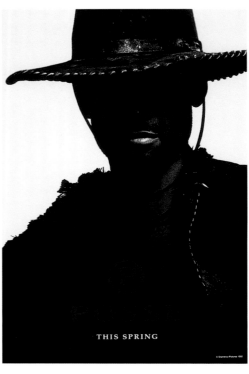

Posse

MOVIE COMPANY
Gramercy Pictures
DISTRIBUTOR OF FILM
Gramercy Pictures
DESIGN FIRM
Frankfurt Balkind Partners
ART DIRECTORS
Randi Braun, Sherwood Andrews
DESIGNER
Randi Braun
PHOTOGRAPHER
Albert Watson
CREATIVE DIRECTOR
Peter Bemis

This four-color, black and white photograph was stripped straight from the film material.

Tank Girl

MOVIE COMPANY
MGM
DISTRIBUTOR OF FILM
MGM
DESIGN FIRM
Mike Salisbury Communications Inc.
ART DIRECTOR
Mike Salisbury
DESIGNER
Mike Salisbury
ILLUSTRATOR/ARTIST
Brian Sisson

The hand-drawn image was scanned into the computer and manipulated in Adobe Illustrator and in QuarkXPress.

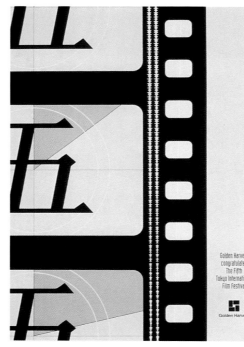

Tokyo Film Festival, advertisement

MOVIE COMPANY
Golden Harvest
DISTRIBUTOR OF FILM
Golden Harvest
DESIGN FIRM
PPA Design Limited
ART DIRECTOR
Byron Jacobs
DESIGNER
Byron Jacobs

All work created on a Macintosh using Aldus Freehand.

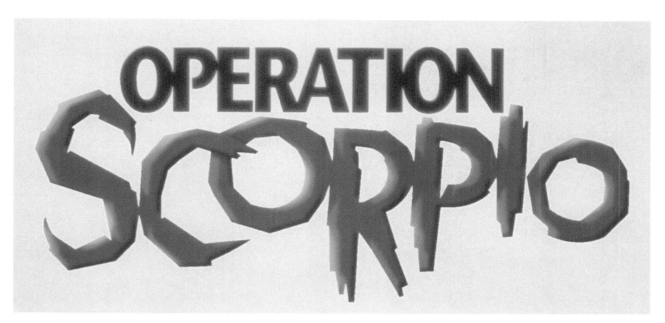

Operation Scorpio
MOVIE COMPANY
Golden Harvest
DISTRIBUTOR OF FILM
Golden Harvest
DESIGN FIRM
PPA Design Limited
ART DIRECTOR
Byron Jacobs
DESIGNER
Byron Jacobs

Typography and artwork for this piece was created in Aldus Freehand, then scanned in and illustrated on Quantel Paintbox®. The title art was applied to lobby cards and posters; all materials were offset printed.

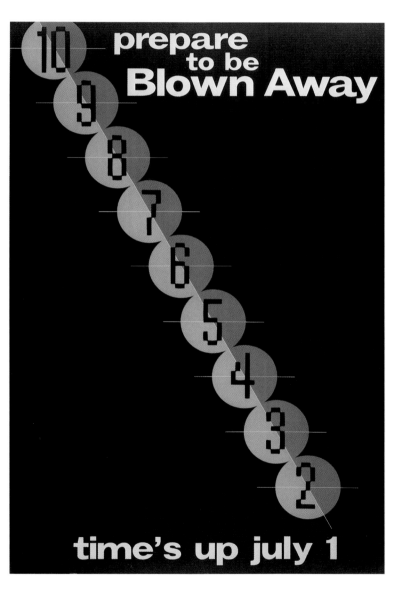

Blown Away
MOVIE COMPANY
MGM
DISTRIBUTOR OF FILM
MGM
DESIGN FIRM
Mike Salisbury Communications Inc.
ART DIRECTOR
Mike Salisbury
DESIGNER
Regina Grosveld
ILLUSTRATOR/ARTIST
Regina Grosveld

The designers created this image with Adobe Illustrator in QuarkXPress. It was then silk-screened with bright colors over plastic for a light box display.

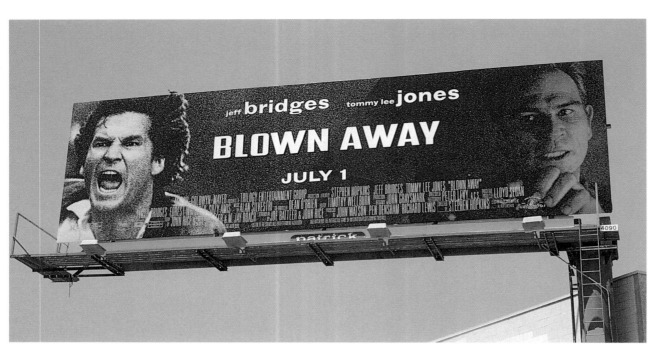

**Blown Away,
outdoor advertisement**

MOVIE COMPANY

MGM/UA

DISTRIBUTOR OF FILM

MGM/UA

DESIGN FIRM

Mike Salisbury Communications Inc.

ART DIRECTOR

Mike Salisbury

ILLUSTRATOR/ARTIST

Alan Williams

Jeff Bridges' head image was creat-
ed in the computer, then the entire
image was mezzo-printed for effect.

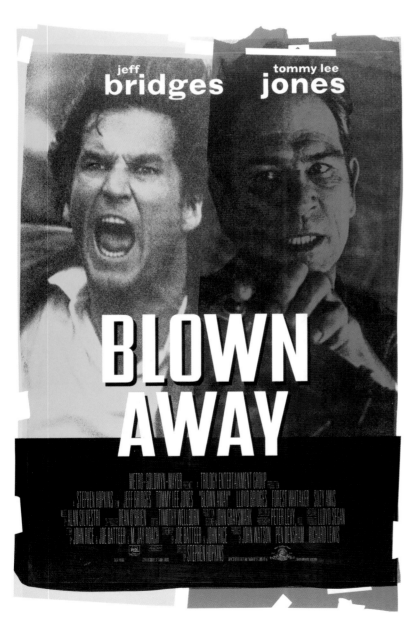

Blown Away

MOVIE COMPANY

MGM/UA

DISTRIBUTOR OF FILM

MGM/UA

DESIGN FIRM

Mike Salisbury Communications Inc.

ART DIRECTOR

Mike Salisbury

DESIGNER

Mike Salisbury

PHOTOGRAPHERS

Bruce Birmelow, Joel D. Warren

ILLUSTRATOR/ARTIST

Alan Williams

Jeff Bridges' face image was created
from different heads, and his eyes
were created with a computer. The
color is acetate overlays, and the
entire art was photographed for off-
set printing.

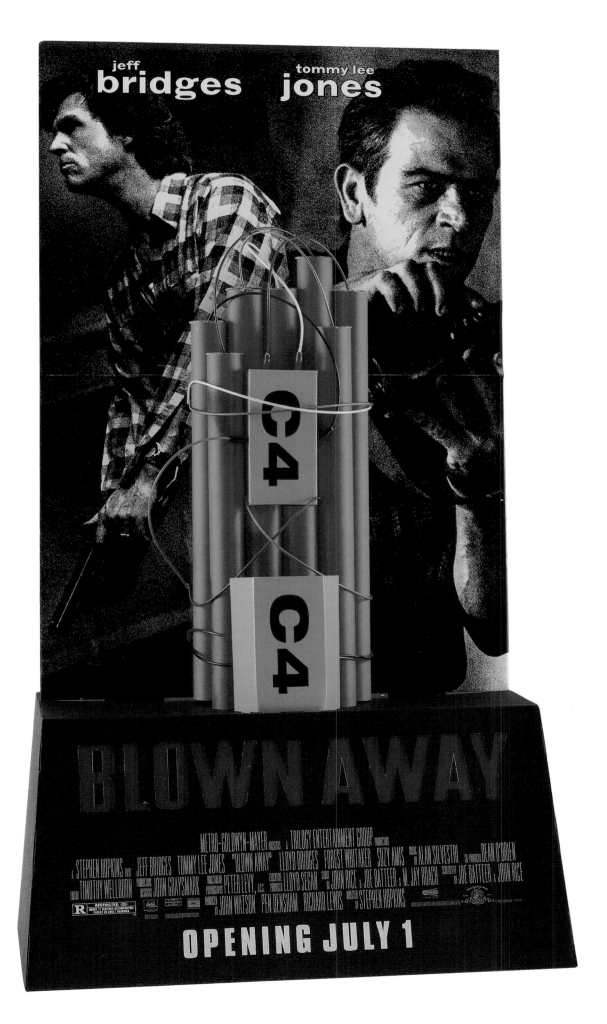

Blown Away

MOVIE COMPANY
MGM/UA

DISTRIBUTOR OF FILM
MGM/UA

DESIGN FIRM
JJ&A

ART DIRECTOR
Tami Masuda

DESIGNER
JJ&A

This four-color image was created on foam board with three flashing lights, PVC tubing, and incandescent lights.

The movie poster/advertisement reads:

TWENTIETH CENTURY-FOX Presents

A KINGS ROAD Production

A RICHARD LONCRAINE Film

DENNIS QUAID LOUIS GOSSETT, JR.

ENEMY
MINE

Executive Producer Screenplay by
STANLEY O'TOOLE EDWARD KHMARA
Based on the story by Produced by
BARRY LONGYEAR STEPHEN FRIEDMAN
Directed by
RICHARD LONCRAINE

For Release Summer, 1985.

Enemy Mine,
trade advertisement

MOVIE COMPANY

Twentieth Century Fox

DISTRIBUTOR OF FILM

Twentieth Century Fox

DESIGN FIRM

Mike Salisbury Communications Inc.

ART DIRECTOR

Mike Salisbury

DESIGNER

Jeff Wack

The designers created the imaginary
planets with an airbrush.

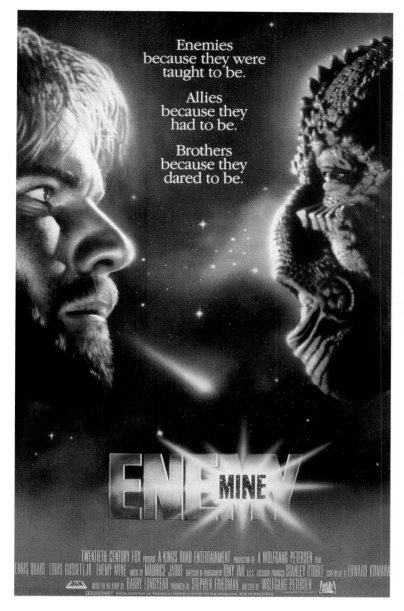

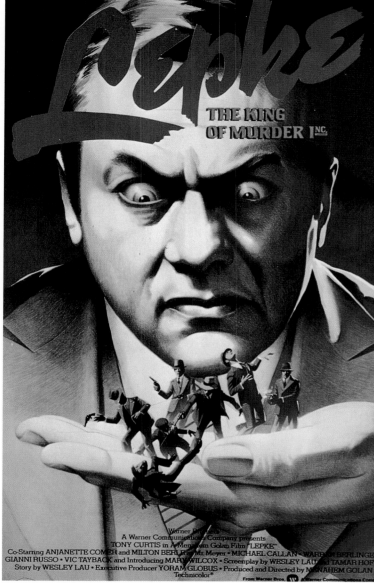

Enemy Mine

MOVIE COMPANY

Twentieth Century Fox

DISTRIBUTOR OF FILM

Twentieth Century Fox

DESIGN FIRM

Mike Salisbury Communications Inc.

ART DIRECTOR

Mike Salisbury

DESIGNER

Mike Salisbury

ILLUSTRATOR/ARTIST

Jeff Wack

The black and white head images
were stripped together on paper and
painted by hand.

Lepke, poster

MOVIE COMPANY

Warner Bros.

DISTRIBUTOR OF FILM

Warner Bros.

DESIGN FIRM

Mike Salisbury Communications Inc.

ART DIRECTOR

Mike Salisbury

DESIGNER

Mike Salisbury

ILLUSTRATOR/ARTIST

W.T. Vinson

The design was created using
watercolor.

Janis, poster

MOVIE COMPANY

Universal Pictures

DISTRIBUTOR OF FILM

Universal Pictures

PHOTOGRAPHER

Jim Marshall

ILLUSTRATOR/ARTIST

Charlie Wild

To give this documentary film a feature feeling, the designers used innovative type and a clean background.

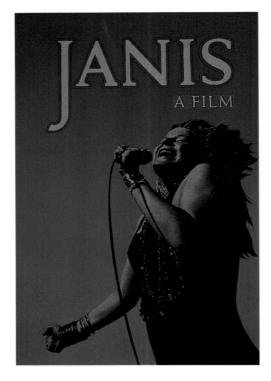

Actress

MOVIE COMPANY

Golden Harvest

DISTRIBUTOR OF FILM

Golden Harvest

DESIGN FIRM

PPA Design Limited

ART DIRECTOR

Byron Jacobs

DESIGNER

Byron Jacobs

The photographic images and mechanical artwork, including type prepared with Aldus Freehand, were color-separated and offset printed.

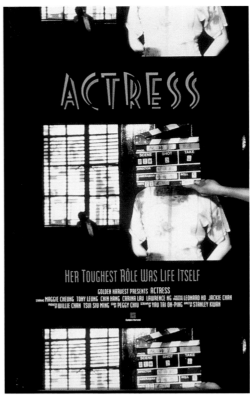

Rachel-Rachel, poster

MOVIE COMPANY

Warner Bros.

DISTRIBUTOR OF FILM

Warner Bros.

DESIGN FIRM

Mike Salisbury Communications Inc.

ART DIRECTOR

Mike Salisbury

DESIGNER

Dwight Smith

ILLUSTRATOR/ARTIST

Jeff Wack

This re-release poster was developed with airbrush over photography.

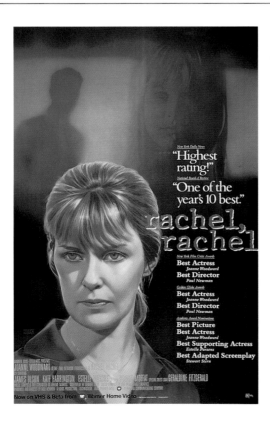

Barcelona

MOVIE COMPANY

Castle Rock Entertainment

DISTRIBUTOR OF FILM

Fine Line Features

DESIGN FIRM

BLT & Associates Inc.

ART DIRECTOR

BLT & Associates Inc.

DESIGNER

BLT & Associates Inc.

PHOTOGRAPHERS

Bob Marshak, Eric Robert

DIGITAL IMAGING

Imagic

The designers used a custom metallic yellow accent and a mother-of-pearl title treatment on this six-color design.

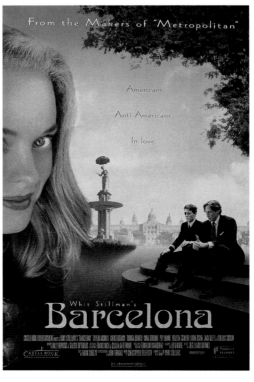

Basic Instinct, poster

MOVIE COMPANY

TriStar Pictures

DISTRIBUTOR OF FILM

TriStar Pictures

DESIGN FIRM

Mike Salisbury Communications Inc.

ART DIRECTORS

Bill Lopez, Mike Salisbury

DESIGNER

Mike Salisbury

ILLUSTRATOR/ARTIST

Jack Upsom

The actors' head images were combined by computer with body-double images for this graphic.

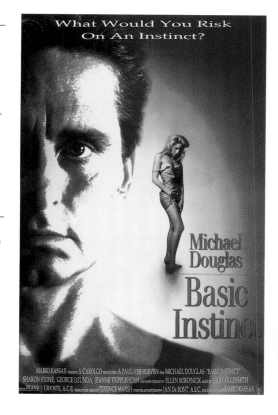

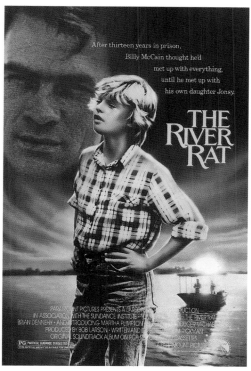

The River Rat, poster

MOVIE COMPANY

Paramount Pictures

DISTRIBUTOR OF FILM

Paramount Pictures

DESIGN FIRM

Mike Salisbury Communications Inc.

ART DIRECTOR

Mike Salisbury

DESIGNER

Terry Lamb

ILLUSTRATOR/ARTIST

Jeff Wack

The images were developed with the use of paint over photographs.

The Cutting Edge

MOVIE COMPANY

MGM

DISTRIBUTOR OF FILM

MGM

DESIGN FIRM

Mike Salisbury Communications Inc.

ART DIRECTOR

Bill Coper

DESIGNER

Mike Salisbury

Designers combined images of the actors' heads, Olympic rings, and unit stills, along with airbrush, to develop this design.

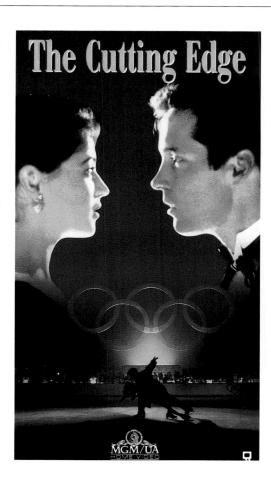

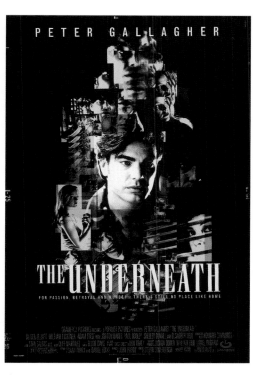

The Underneath

MOVIE COMPANY

Gramercy Pictures

DISTRIBUTOR OF FILM

Gramercy Pictures

DESIGN FIRM

Mike Salisbury Communications Inc.

ART DIRECTOR

Mike Salisbury

DESIGNERS

Ron Brown, Mike Salisbury

ILLUSTRATOR/ARTIST

Ron Brown

All graphics were created in QuarkXPress from various still photographs.

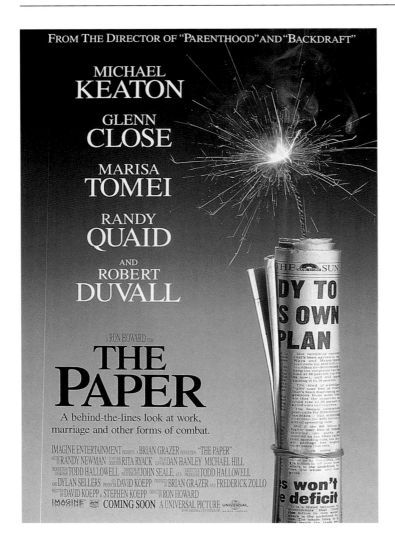

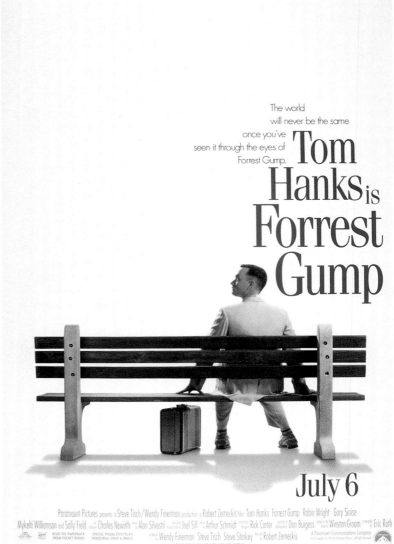

The Paper

MOVIE COMPANY

Universal Pictures,
Imagine Entertainment

DESIGN FIRM

Frankfurt Balkind Partners

ART DIRECTOR

Mike Hammel

CREATIVE DIRECTOR

Peter Bemis

PHOTOGRAPHER

Dennis Dannehl

COPYWRITERS

Ari Sherman, Saul Kanan

Photographs of paper, a wick, and
a spark were placed together on
Quantel Paintbox®.

Forrest Gump

MOVIE COMPANY

Paramount Pictures

DISTRIBUTOR OF FILM

Paramount Pictures

DESIGN FIRM

Frankfurt Balkind Partners

ART DIRECTOR

Rob Tepper

DESIGNER

Rob Tepper

PHOTOGRAPHER

E.J. Camp

CREATIVE DIRECTOR

Peter Bemis

The image of Tom Hanks, the bench,
and the suitcase were stripped out of
a single transparency from a special
shoot. The shadow and retouching
were created and composed
on Quantel Paintbox®.

Forrest Gump,
bus shelter poster
MOVIE COMPANY
Paramount Pictures
DISTRIBUTOR OF FILM
Paramount Pictures
DESIGN FIRM
Frankfurt Balkind Partners
ART DIRECTOR
Peter Bemis
DESIGNER
Rob Tepper
PHOTOGRAPHERS
E.J. Camp, Ron Stenzack
CREATIVE DIRECTOR
Peter Bemis

Two photographs were composited
together and retouched on Quantel
Paintbox®.

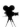

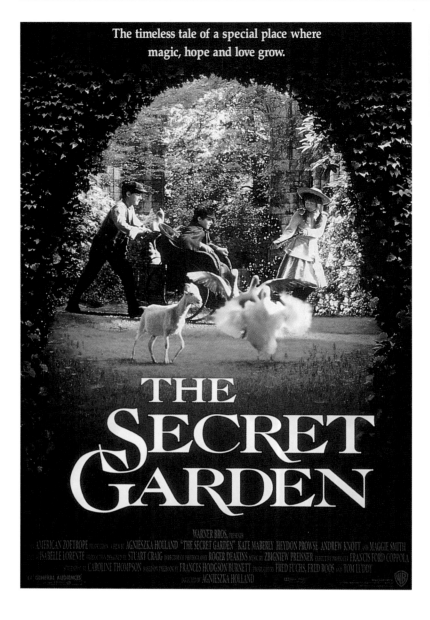

The Secret Garden

MOVIE COMPANY

Warner Bros.

DISTRIBUTOR OF FILM

Warner Bros.

DESIGN FIRM

The Idea Place

ART DIRECTORS

Maseeh Rafani, Jimmy Wachtel

DESIGNERS

Jimmy Wachtel, Maseeh Rafani

PHOTOGRAPHER

Murray Close

ILLUSTRATOR/ARTIST

Myra Wood

Shirley Temple

MOVIE COMPANY

Twentieth Century Fox-
Playhouse Video

DISTRIBUTOR OF FILM

Twentieth Century Fox-
Playhouse Video

DESIGN FIRM

Pelikan Pictures

ART DIRECTOR

Ron Rae

DESIGNER

Ron Rae

ILLUSTRATOR/ARTIST

Gary Ciccarelli

The creator used airbrush and
Prismacolor pencil to produce this
image.

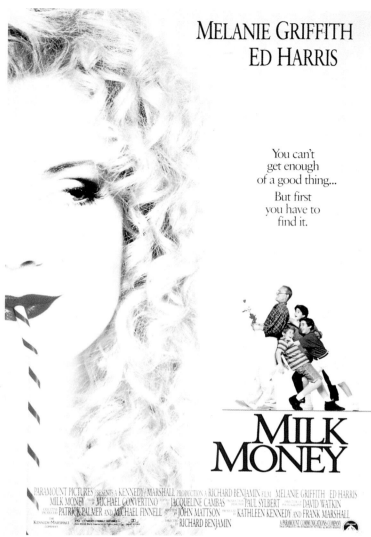

Doghunt
MOVIE COMPANY
Twentieth Century Fox
DESIGN FIRM
Mike Salisbury Communications Inc.
ART DIRECTOR
Mike Salisbury
DESIGNER
Kon Markman
ILLUSTRATOR/ARTIST
John Soli

Milk Money
MOVIE COMPANY
The Kennedy/Marshall Co.
DISTRIBUTOR OF FILM
Paramount Pictures
DESIGN FIRM
BLT & Associates Inc.
ART DIRECTOR
BLT & Associates Inc.
DESIGNER
BLT & Associates Inc.
PHOTOGRAPHERS
Greg Gorman, Pete Tangen
DIGITAL IMAGING
Cronopious

This 5-color image has a special hit
of red.

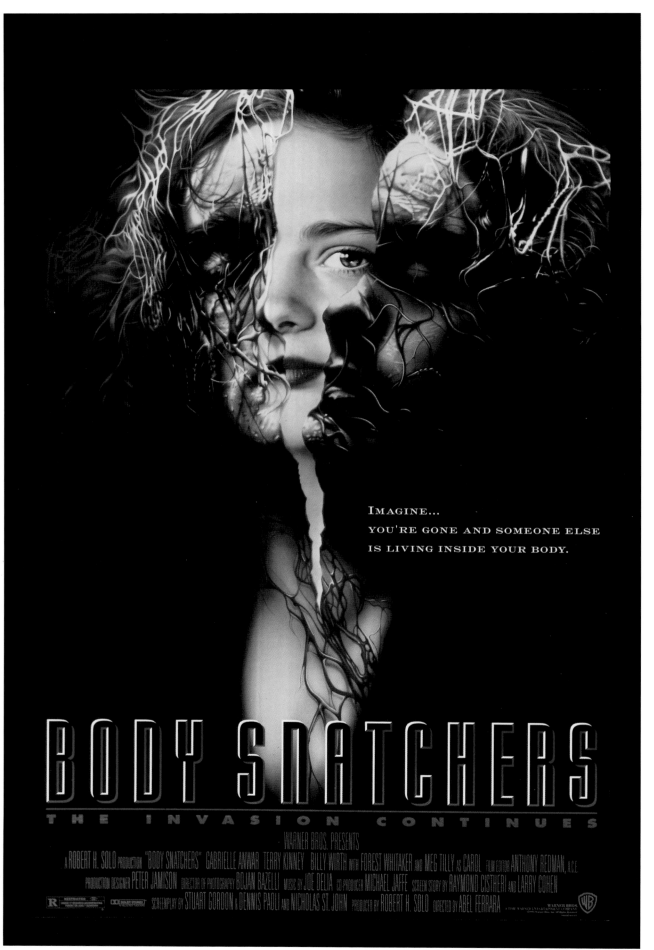

Body Snatchers

MOVIE COMPANY

Warner Bros.

DISTRIBUTOR OF FILM

Warner Bros.

AGENCY

B.D. Fox & Friends, Inc. Advertising

ART DIRECTOR

Rob Biro

DESIGNER

Rob Biro

PHOTOGRAPHER

Dave Robinette

PHOTO ILLUSTRATOR

Mike Bryan

COPYWRITER

Rich Fox

The images of the duplicate beings were designed with the use of scrap metal and photo-illustration.

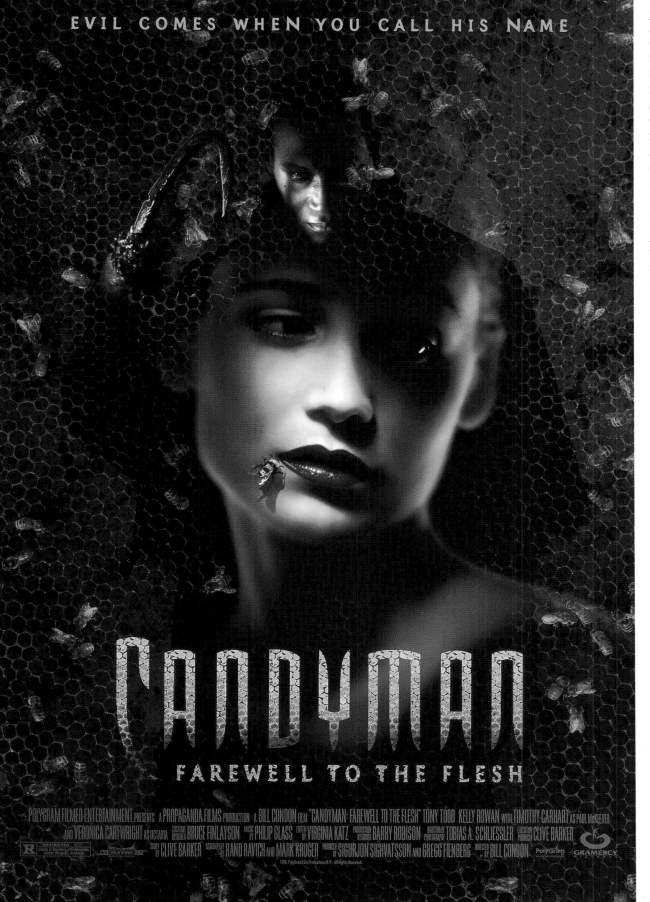

EVIL COMES WHEN YOU CALL HIS NAME

CANDYMAN

FAREWELL TO THE FLESH

Candyman: Farewell To the Flesh

MOVIE COMPANY
Gramercy Pictures, Inc.

DISTRIBUTOR OF FILM
Polygram Filmed Entertainment

DESIGN FIRM
Margo Chase Design

CREATIVE DIRECTOR
Samantha Hart

ART DIRECTOR
Margo Chase

PHOTOGRAPHER
Nels Israelson

DESIGNER/ILLUSTRATOR
Brian Hunt

The elements were photographed
separately and scanned into a
Macintosh. The final image was
montaged in Adobe Photoshop for
client approval and then recreated on
Quantel Paintbox® for output to
separations.

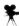

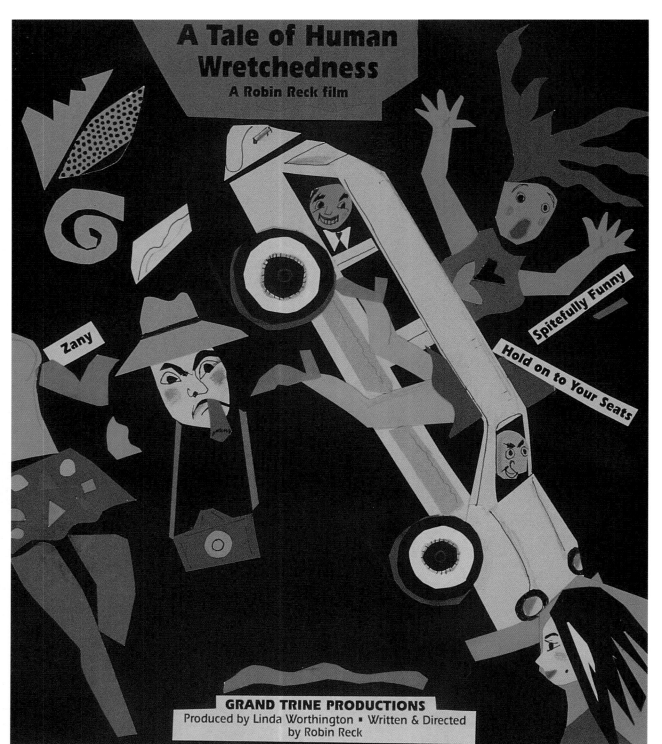

A Tale of Human Wretchedness

MOVIE COMPANY
Grand Trial Productions
DESIGN FIRM
Karyl Klopp Design
ALL DESIGN
Karyl Klopp

This image was created using a collage of drawings and cut papers on black illustration board. Laser type from Aldus Freehand was Xeroxed on colored paper and placed into the collage cutout.

The Mask, self-promotion
DESIGN FIRM
Jim Langman Illus.
ALL DESIGN
Jim Langman

For this promotion, airbrushed ink allowed for heavy erasing of ink to create textures. This technique allows for pure color and great detail to create a surrealistic look with photographic qualities.

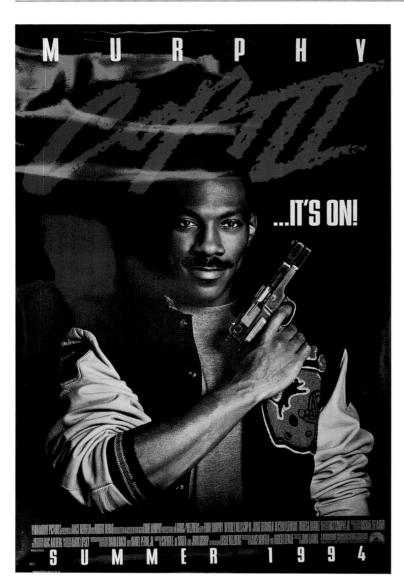

Beverly Hills Cop III, teaser campaign

MOVIE COMPANY
Paramount Pictures
DISTRIBUTOR OF FILM
Paramount Pictures
DESIGN FIRM
BLT & Associates Inc.
ART DIRECTOR
BLT & Associates Inc.
DESIGNER
BLT & Associates Inc.
PHOTOGRAPHER
Greg Gorman
DIGITAL IMAGING
Digital Transparency

The designers used a red touch plate with a 5-color printing process to create this image.

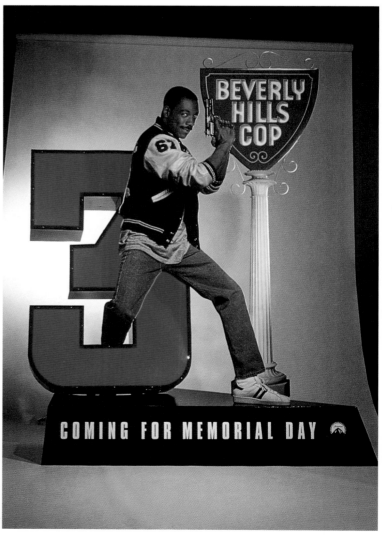

Beverly Hills Cop III, standee

MOVIE COMPANY
Paramount Pictures
DISTRIBUTOR OF FILM
Paramount Pictures
DESIGN FIRM
BLT & Associates Inc.
ART DIRECTOR
BLT & Associates Inc.
DESIGNER
BLT & Associates Inc.
PHOTOGRAPHER
Greg Gorman
PRODUCTION/MANUFACTURING
Drissi Advertising

This standee was created with the use of a 4-color printing process.

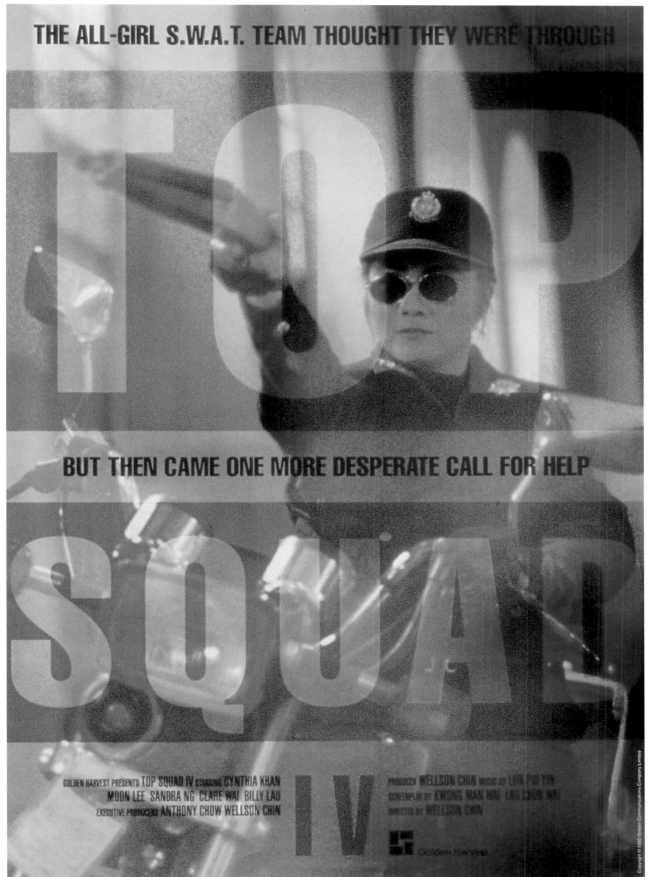

Top Squad

MOVIE COMPANY
Golden Harvest

DISTRIBUTOR OF FILM
Golden Harvest

DESIGN FIRM
PPA Design Limited

ART DIRECTOR
Byron Jacobs

DESIGNER
Byron Jacobs

The photographic images were supplied by the client. The designers prepared the text in Aldus Freehand then retouched it in Adobe Photoshop.

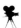

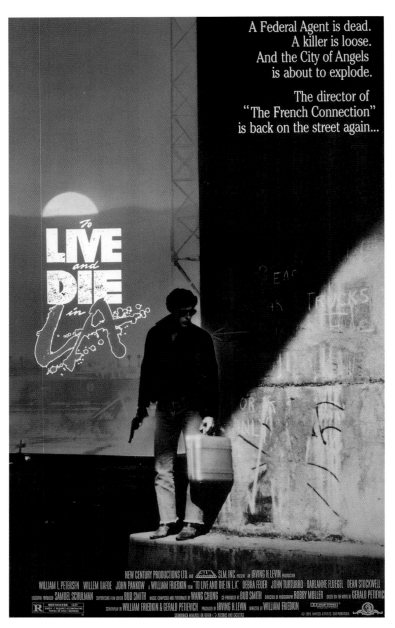

Live and Die in L.A.

MOVIE COMPANY

MGM

DISTRIBUTOR OF FILM

MGM

DESIGN FIRM

Mike Salisbury Communications Inc.

ART DIRECTOR

Mike Salisbury

DESIGNER

Mike Salisbury

ILLUSTRATOR/ARTIST

Terry Lamb

The gun, sky, and depth were added by hand to an original photograph. This was the first use of blood on a one-sheet design.

The Saint of Fort Washington

MOVIE COMPANY

Warner Bros.

DISTRIBUTOR OF FILM

Warner Bros.

DESIGN FIRM

The Idea Place

ART DIRECTORS

Maseeh Rafani, Jimmy Wachtel

DESIGNERS

Jimmy Wachtel, Maseeh Rafani

PHOTOGRAPHER

Bob Greene

ILLUSTRATOR/ARTIST

Myra Wood

The logo for this design was created with the use of a fifth color.

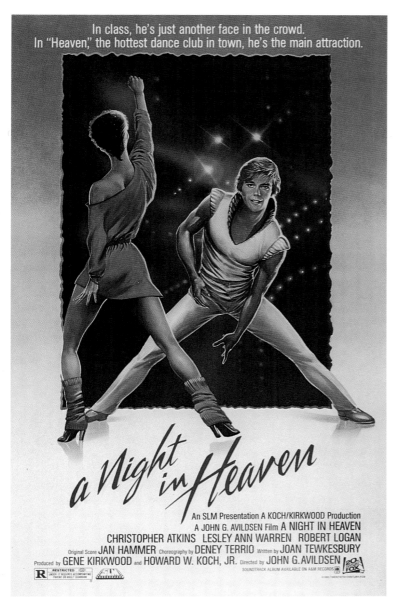

In class, he's just another face in the crowd.
In "Heaven," the hottest dance club in town, he's the main attraction.

a Night in Heaven

An SLM Presentation A KOCH/KIRKWOOD Production
A JOHN G. AVILDSEN Film A NIGHT IN HEAVEN
CHRISTOPHER ATKINS LESLEY ANN WARREN ROBERT LOGAN
Original Score JAN HAMMER Choreography by DENEY TERRIO Written by JOAN TEWKESBURY
Produced by GENE KIRKWOOD and HOWARD W. KOCH, JR. Directed by JOHN G. AVILDSEN
SOUNDTRACK ALBUM AVAILABLE ON A&M RECORDS

A Night in Heaven
MOVIE COMPANY
Twentieth Century Fox
DISTRIBUTOR OF FILM
Twentieth Century Fox
DESIGN FIRM
Mike Salisbury Communications Inc.
ART DIRECTOR
Mike Salisbury
DESIGNER
Mike Salisbury

Image created with use of pastel
illustration.

Dead of Winter
MOVIE COMPANY
MGM
DISTRIBUTOR OF FILM
MGM
DESIGN FIRM
Mike Salisbury Communications Inc.
ART DIRECTOR
Mike Salisbury
DESIGNER
Mike Salisbury
PHOTOGRAPHER
Unit

The designers screen-printed this
image over plastic for backlighting.

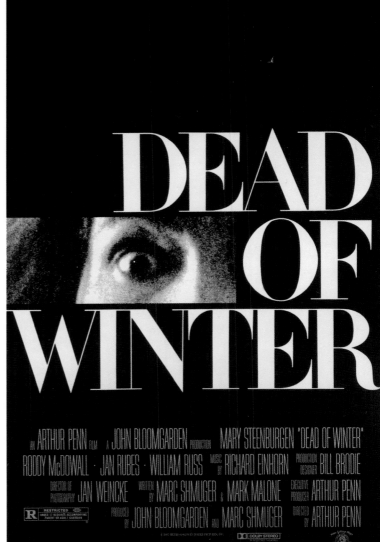

DEAD OF WINTER

AN ARTHUR PENN FILM A JOHN BLOOMGARDEN PRODUCTION MARY STEENBURGEN "DEAD OF WINTER"
RODDY McDOWALL · JAN RUBES · WILLIAM RUSS MUSIC BY RICHARD EINHORN PRODUCTION DESIGNER BILL BRODIE
DIRECTOR OF PHOTOGRAPHY JAN WEINCKE WRITTEN BY MARC SHMUGER & MARK MALONE EXECUTIVE PRODUCER ARTHUR PENN
PRODUCED BY JOHN BLOOMGARDEN AND MARC SHMUGER DIRECTED BY ARTHUR PENN
DOLBY STEREO

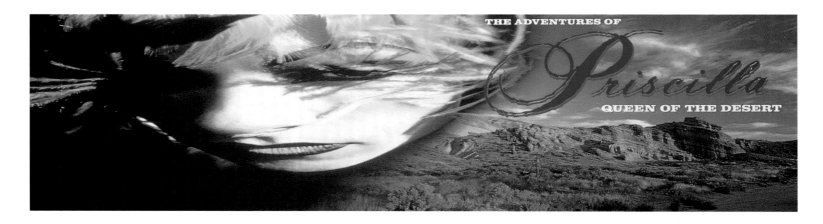

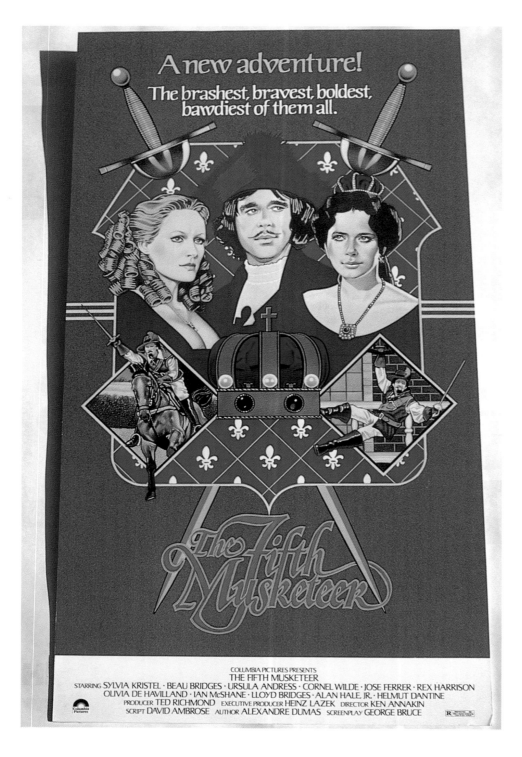

Priscilla Queen of the Desert

MOVIE COMPANY
Polygram Filmed Entertainment

DISTRIBUTOR OF FILM
Gramercy Pictures

DESIGN FIRM
BRD Design

ART DIRECTORS
Tabitha Delatorre, Neville Burtis

DESIGNER
Anne Kelly

This film image was retouched in Quantel Paintbox®.

The Fifth Musketeer, poster

DESIGN FIRM
Mike Salisbury Communications Inc.

ART DIRECTOR
Tony Seiniger

DESIGNER
Mike Salisbury

ILLUSTRATOR/ARTIST
Gary Myer

All elements of this graphic were painted as one piece, including the title.

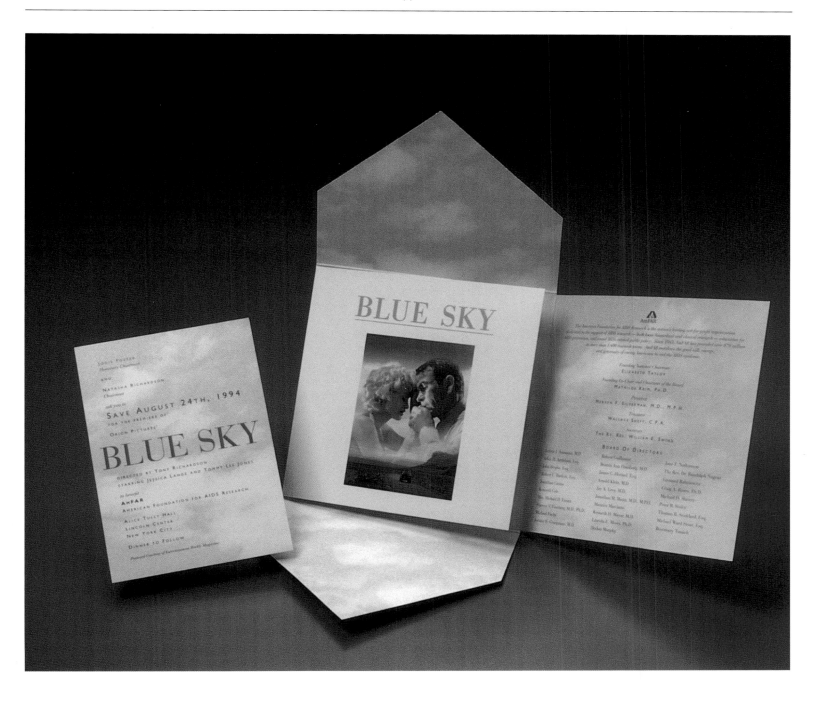

Blue Sky, invitation

MOVIE COMPANY

Orion

DISTRIBUTOR OF FILM

Orion

DESIGN FIRM

Platinum Design

ART DIRECTOR

Kathleen Phelps

DESIGNER

Pernillia Nilsson

This invitation for the "Blue Sky"
movie premiere was created with the
sky image as the main visual. The
design was produced in QuarkXPress
and printed in 4-color process (with
dull varnish).

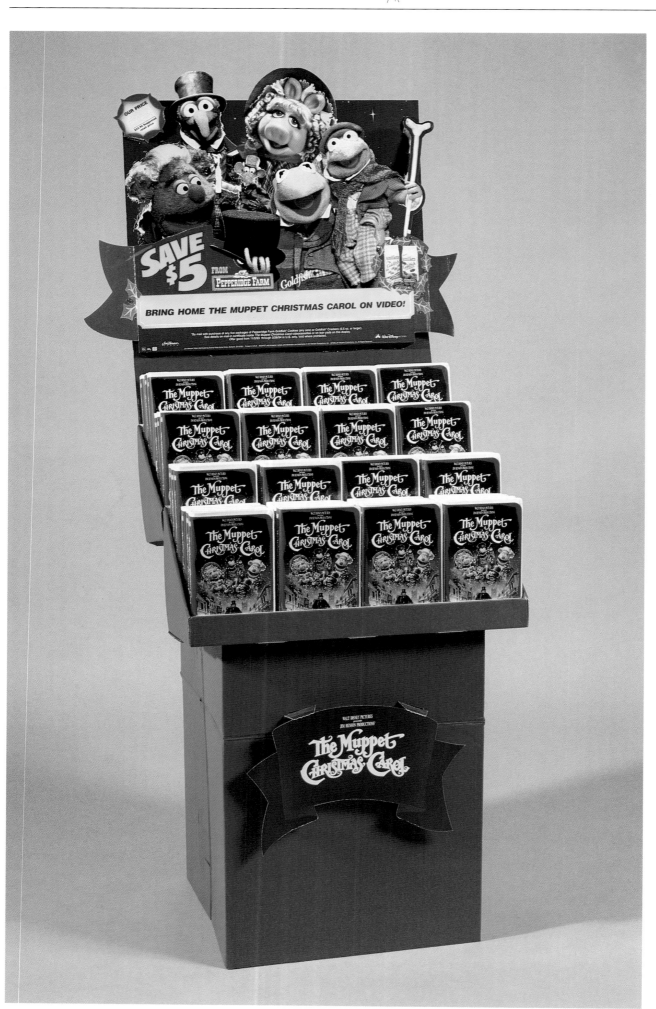

Muppet Christmas Carol

MOVIE COMPANY

Buena Vista Home Video, Inc.

DESIGN FIRM

The Dyment Company

ART DIRECTOR

Jackson Dillard

DESIGNER

John Strejan

The 4-color process sheets that designers used for this image were mounted to corrugated cardboard.

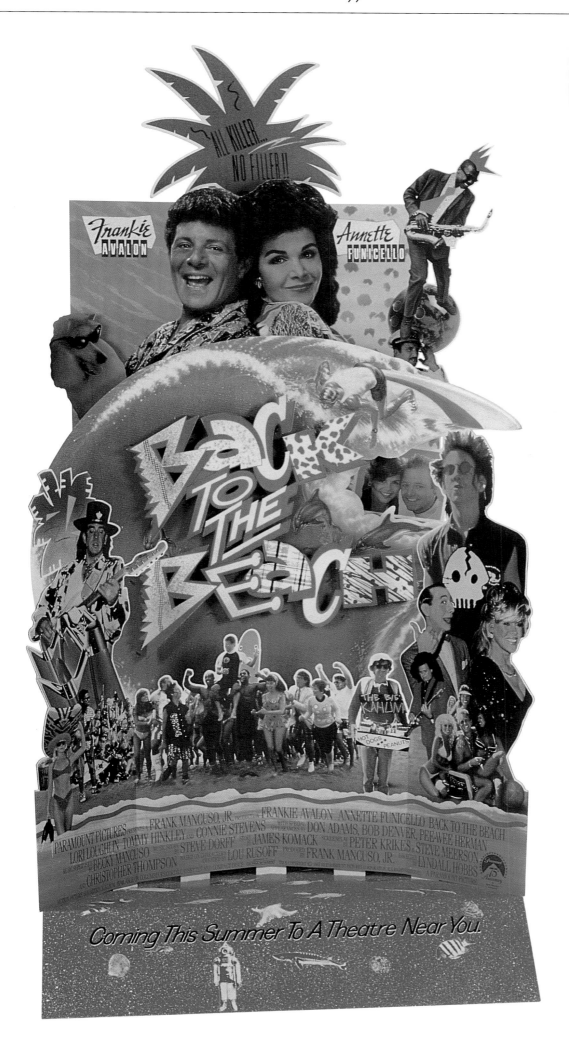

Back to the Beach, standee

MOVIE COMPANY
Paramount Pictures
DISTRIBUTOR OF FILM
Paramount Pictures
DESIGN FIRM
Mike Salisbury Communications Inc.
ART DIRECTOR
Mike Salisbury
DESIGNER
Terry Lamb
PHOTOGRAPHER
Unit
ILLUSTRATOR/ARTIST
Terry Lamb

This six-foot-tall standee is electrically animated.

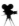

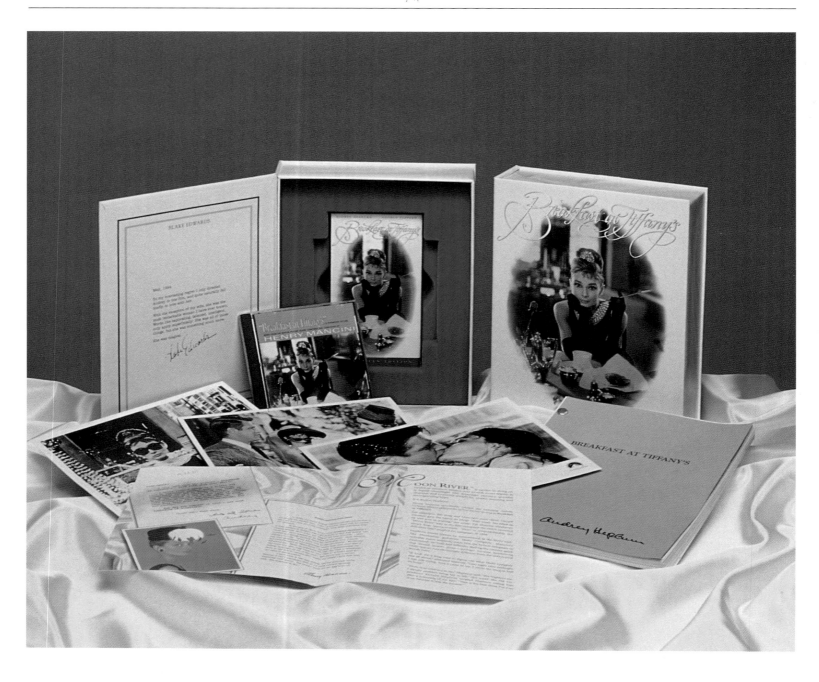

Breakfast at Tiffany's
MOVIE COMPANY
Paramount Home Video
DESIGN FIRM
30sixty design, Inc.
ART DIRECTOR
Henry Vizcarra
DESIGNERS
Vu Tran, Brian Lane

The foil-stamped logo for this video packaging was hand-drawn, while the artwork was created in QuarkXPress and Adobe Photoshop. The final packaging was printed 4-color.

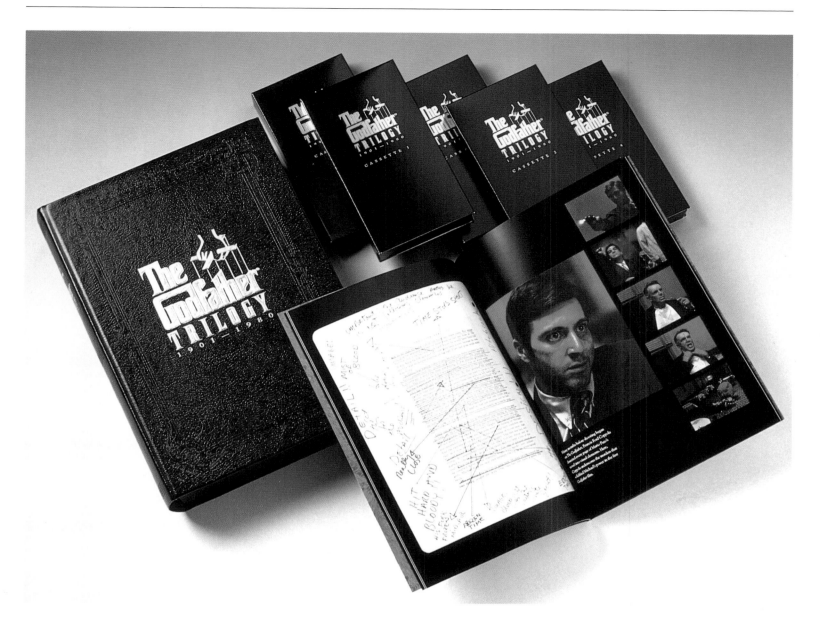

The Godfather

MOVIE COMPANY

Paramount Home Video

DESIGN FIRM

30sixty design, Inc.

ART DIRECTOR

Henry Vizcarra

DESIGNER

Vu Tran

The designers created this packaging for a special edition videocassette of "The Godfather Trilogy."

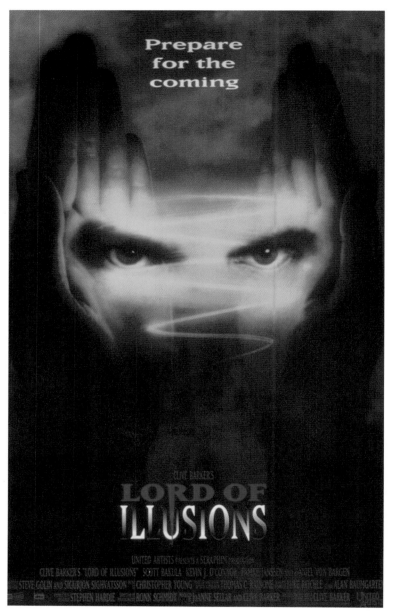

Lord of Illusions

MOVIE COMPANY

MGM

DISTRIBUTOR OF FILM

MGM

DESIGN FIRM

Frankfurt Balkind Partners

CREATIVE DIRECTOR

Peter Bemis

DESIGNER

Mike Hammel

PHOTOGRAPHER

Glen Gyssler

ILLUSTRATOR/ARTIST

Metafor

The designers scanned stock photography and unit photography then manipulated them on a Sheima Seiki System.

Tales from the Hood

MOVIE COMPANY

Savoy Pictures/Kenji Theilstrom

DISTRIBUTOR OF FILM

Savoy Pictures

DESIGN FIRM

Frankfurt Balkind Partners

CREATIVE DIRECTOR

Peter Bemis

DESIGNER

Brett Wickens

PHOTOGRAPHER

Jack Andersen

ILLUSTRATOR/ARTIST

Metafor

The hand-painted skull image with sun glasses and gold tooth was supplied to the photographer, scanned, and manipulated on a Sheima Seiki System.

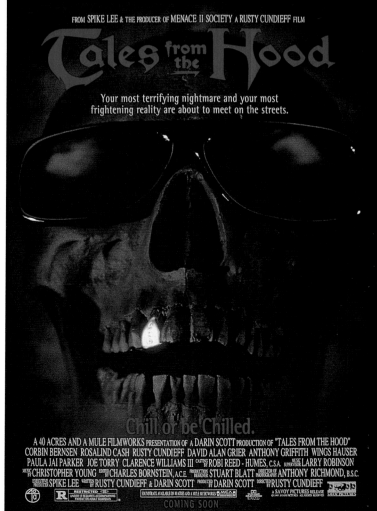

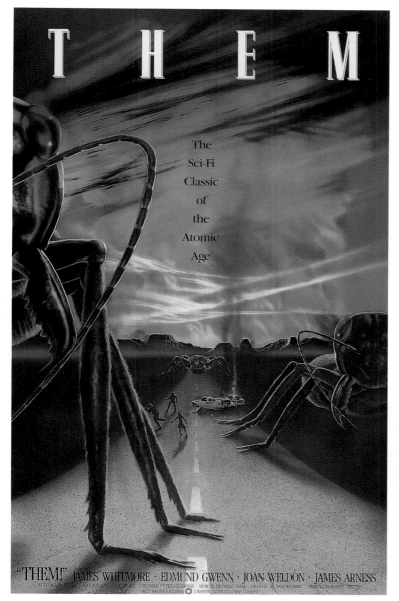

Them, poster

MOVIE COMPANY

Warner Bros.

DISTRIBUTOR OF FILM

Warner Bros.

DESIGN FIRM

Mike Salisbury Communications Inc.

ART DIRECTOR

Mike Salisbury

ILLUSTRATOR/ARTIST

Jeff Wack

This design was created using air-brush over photographs.

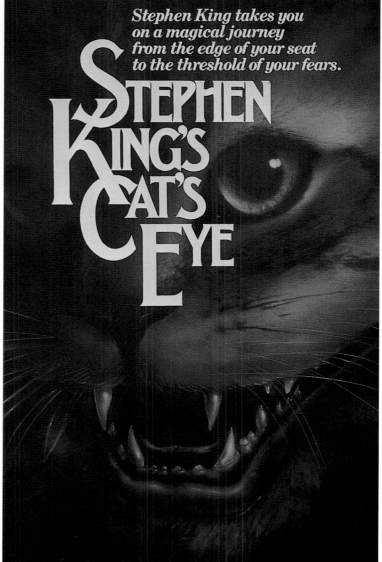

Cats Eye, poster

MOVIE COMPANY

MGM

DISTRIBUTOR OF FILM

MGM

DESIGN FIRM

Mike Salisbury Communications Inc.

ART DIRECTOR

Mike Salisbury

DESIGNER

Mike Salisbury

ILLUSTRATOR/ARTIST

Jeff Wack

This poster was designed using an airbrush.

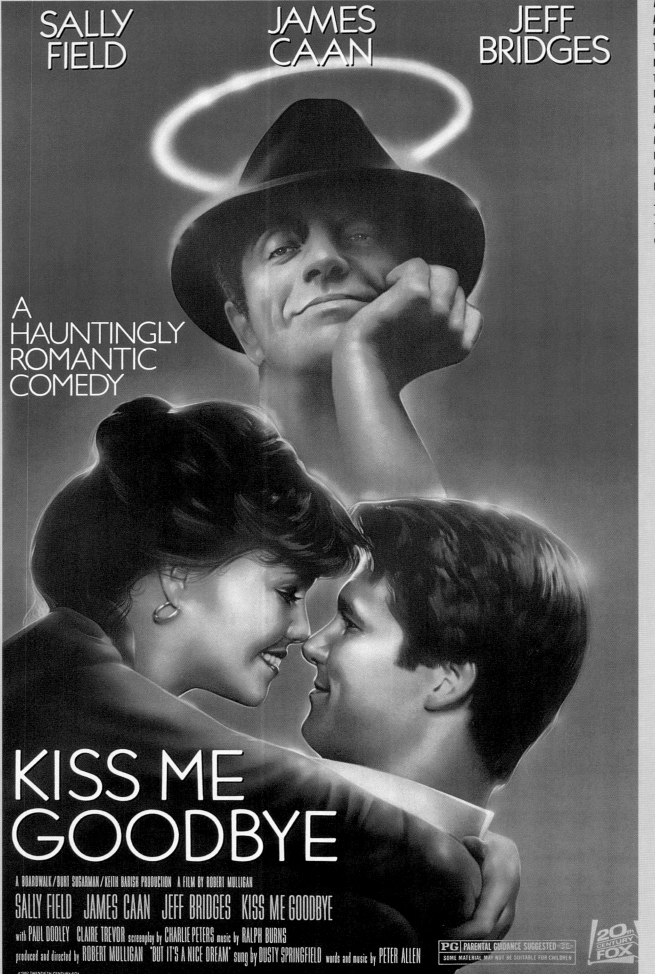

Kiss Me Goodbye,
poster

MOVIE COMPANY
Twentieth Century Fox

DISTRIBUTOR OF FILM
Twentieth Century Fox

DESIGN FIRM
Mike Salisbury Communications Inc.

ART DIRECTOR
Mike Salisbury

DESIGNER
Mike Salisbury

ILLUSTRATOR/ARTIST
Jeff Wack

The designers used airbrushed paint over photographs to create this image.

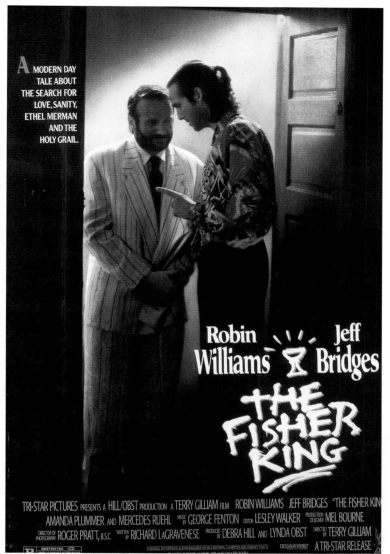

Fisher King

MOVIE COMPANY

TriStar Pictures

DISTRIBUTOR OF FILM

TriStar Pictures

DESIGN FIRM

Mike Salisbury Communications Inc.

ART DIRECTOR

Mike Salisbury

DESIGNER

Mike Salisbury

The designers retouched a scanned still to eliminate furniture. In the computer, shadows were added along with lighting effects, and designers created a face on Robin Williams.

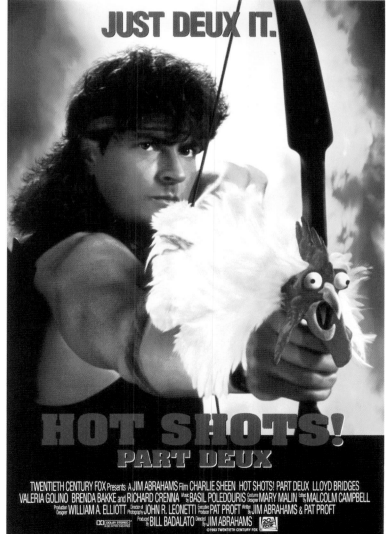

Hot Shots! Part Deux

MOVIE COMPANY

Twentieth Century Fox

DISTRIBUTOR OF FILM

Twentieth Century Fox

AGENCY

B.D. Fox & Friends, Inc.

Advertising

ART DIRECTORS

Garrett Burke, Mark Weinstein

DESIGNER

Garrett Burke

PHOTOGRAPHERS

Ron Groeper, Bruce Birmelin

QUANTEL ARTIST

Page Wood

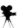

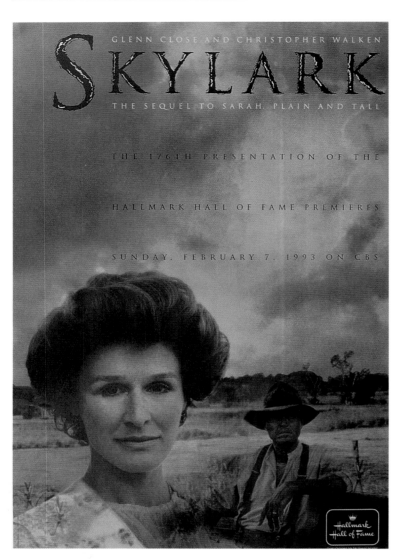

Skylark

DISTRIBUTOR OF FILM

A Self Productions, Inc. & Trillium
Productions, Inc. Production

DESIGN FIRM

Muller + Company

ART DIRECTOR

John Muller

DESIGNER

Scott Chapman

The creators sandwiched and
scanned two transparencies.
Color was manipulated in Adobe
Photoshop, and a composite trans-
parency was output and scanned for
reproduction.

A Place for Annie

DISTRIBUTOR OF FILM

A Self Productions, Inc. & Trillium
Productions Inc. production

DESIGN FIRM

Muller + Company

ART DIRECTOR

John Muller

DESIGNER

Scott Chapman

PHOTOGRAPHERS

Hallmark staff

Hand-drawn type was scanned for
this logo. Low-resolution scans were
used for position, and the main
image was assembled in Adobe
Photoshop and output as film. The
pieces were printed offset.

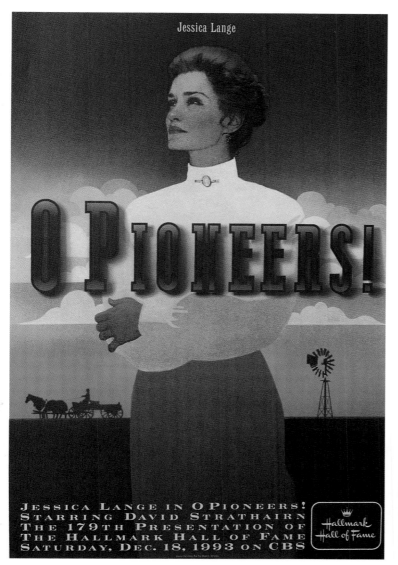

Jessica Lange

O Pioneers!

DISTRIBUTOR OF FILM
A Craig Anderson Production in
association with Lorimar Television
DESIGN FIRM
Muller + Company
ART DIRECTOR
John Muller
DESIGNER
Scott Chapman
ILLUSTRATOR/ARTIST
Mark English

Hand-drawn type was scanned for
this logo. Low-resolution scans were
used for position, and the main
image was assembled in Adobe
Photoshop and output as film. The
pieces were printed offset.

**To Dance with the
White Dog**

DISTRIBUTOR OF FILM
A Self Productions, Inc. & Trillium
Productions, Inc. Production
DESIGN FIRM
Muller + Company
ART DIRECTOR
John Muller
DESIGNER
Scott Chapman
ILLUSTRATOR/ARTIST
Mark English

This visual was a conventional illus-
tration. The basic type was built in
Adobe Illustrator and used as a tem-
plate for Sci-tex manipulation. Pieces
were printed offset lithography.

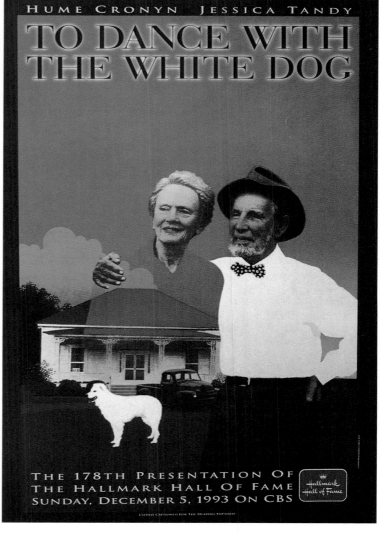

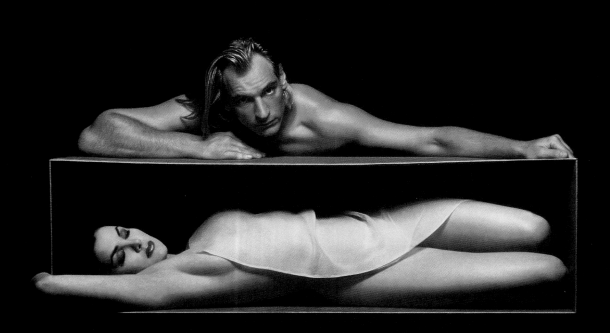

JULIAN SANDS • SHERILYN FENN

A DEEP, DARK

OBSESSION

THAT BARES

A WOMAN'S

BODY AND

A MAN'S SOUL.

Boxing Helena
SOMETIMES LOVE IS A PRISON

MOVIE COMPANY
Republic Pictures
DISTRIBUTOR OF FILM
Republic Pictures
AGENCY
B.D. Fox & Friends, Inc.
Advertising
ART DIRECTOR
Kim Zimmerman
DESIGNER
Kim Zimmerman
PHOTOGRAPHER
Neil Kirk
QUANTEL ARTIST
Page Wood
COPYWRITER
Cheryl Kellough

The box in this design was created specifically to the dimensions of actress Sherilyn Fenn's body. Retouching included opaquing the fabric on her body.

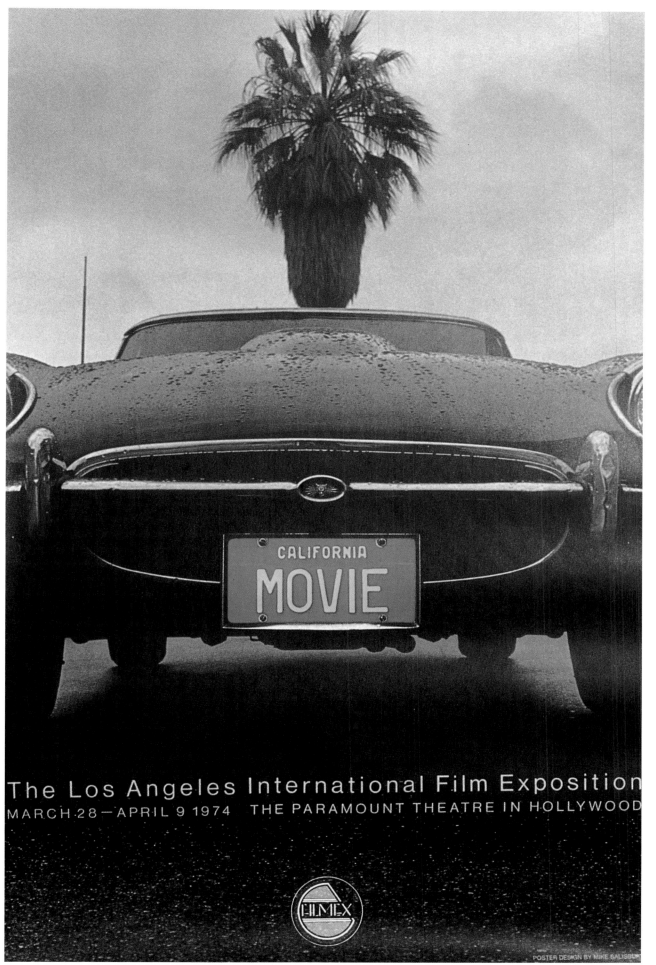

***Los Angeles
International Film
Exposition, poster***
MOVIE COMPANY
Filmex
DESIGN FIRM
Mike Salisbury Communications Inc.
ART DIRECTOR
Mike Salisbury
DESIGNER
Mike Salisbury
PHOTOGRAPHER
Mike Salisbury

Original photography was manipulated
by computer to make the car appear
to be within a tree trunk.

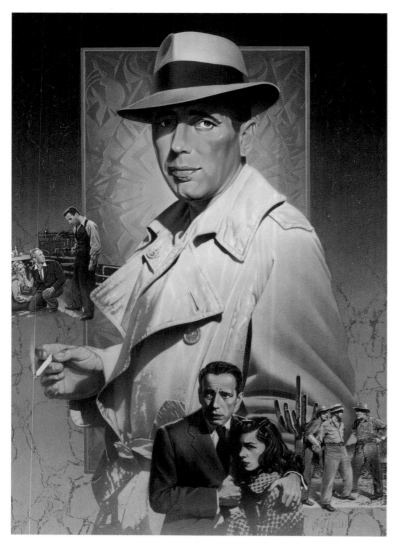

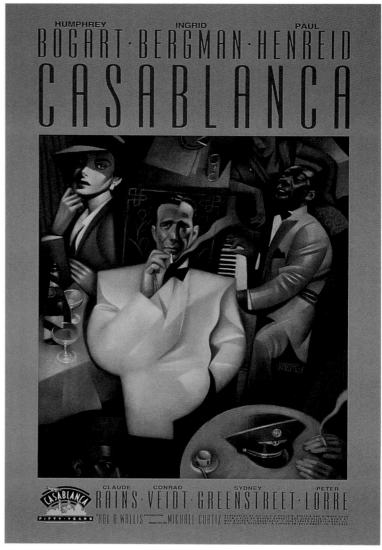

Spotlight on
Humphrey Bogart
MOVIE COMPANY
CBS Fox Video
DISTRIBUTOR OF FILM
CBS Fox Video
DESIGN FIRM
Pelikan Pictures
ART DIRECTOR
Ron Rae
DESIGNER
Ron Rae
ILLUSTRATOR/ARTIST
Gary Ciccarelli

The designer created this image with
airbrush and Prismacolor pencil.

Casablanca
MOVIE COMPANY
Turner Entertainment Co.,
Warner Bros.
DISTRIBUTOR OF FILM
Turner Entertainment Co.
DESIGN FIRM
Tracy Sabin Graphic Design
ART DIRECTOR
Joseph Swaney
DESIGNER
Tracy Sabin
ILLUSTRATOR/ARTIST
Gary Kelley

The creators made this design with
medium pastels, and then separated
it from a transparency.

Casablanca, press kit

MOVIE COMPANY

Turner Entertainment Co.,
Warner Bros.

DISTRIBUTOR OF FILM

Turner Entertainment Co.

DESIGN FIRM

Tracy Sabin Graphic Design

ART DIRECTOR

Joseph Swaney

DESIGNER

Tracy Sabin

PHOTOGRAPHER

Studio Archives

LOGO ARTIST

Tracy Sabin

The logo was created with handcut
amberlith, and the design was done
in Pagestream on the Amiga.

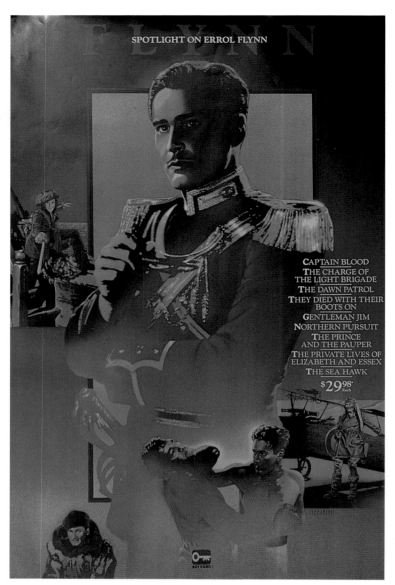

Spotlight on Errol Flynn

MOVIE COMPANY

CBS Fox Video

DISTRIBUTOR OF FILM

CBS Fox Video

DESIGN FIRM

Pelikan Pictures

ART DIRECTOR

Ron Rae

DESIGNER

Ron Rae

ILLUSTRATOR/ARTIST

Gary Ciccarelli

The designer used airbrush and Prismacolor pencil for this piece.

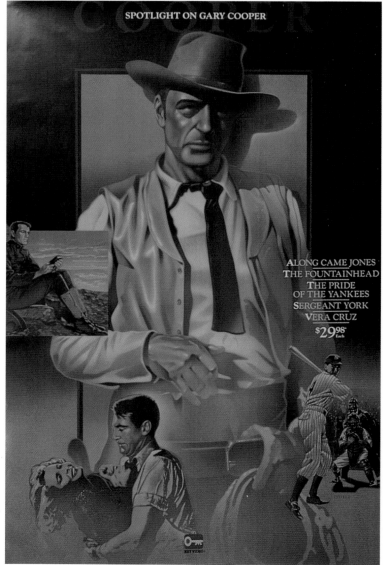

Spotlight on Gary Cooper

MOVIE COMPANY

CBS Fox Video

DISTRIBUTOR OF FILM

CBS Fox Video

DESIGN FIRM

Pelikan Pictures

ART DIRECTOR

Ron Rae

DESIGNER

Ron Rae

ILLUSTRATOR/ARTIST

Gary Ciccarelli

Airbrush and Prismacolor pencil were used by the designer for this image.

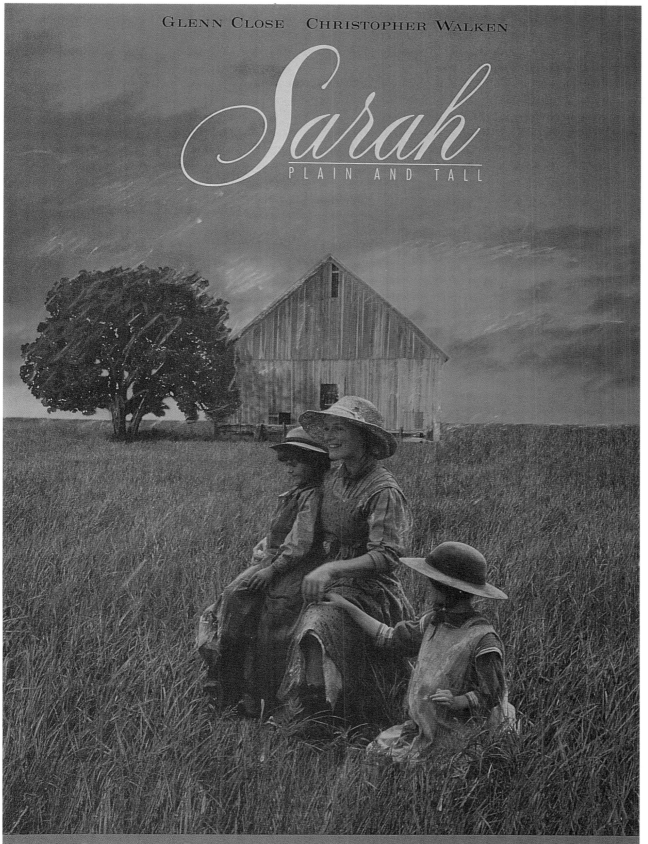

GLENN CLOSE CHRISTOPHER WALKEN

Sarah
PLAIN AND TALL

GLENN CLOSE AND CHRISTOPHER WALKEN IN "SARAH, PLAIN AND TALL"

THE 175TH PRESENTATION OF THE HALLMARK HALL OF FAME

Hallmark
Hall of Fame

SATURDAY, DECEMBER 19, 1992 ON CBS TELEVISION

CLOSED CAPTIONED FOR THE HEARING IMPAIRED

Sarah Plain and Tall

DISTRIBUTOR OF FILM
A Self Productions, Inc. & Trillium
Productions, Inc. production

DESIGN FIRM
Muller + Company

ART DIRECTOR
John Muller

ILLUSTRATOR/ARTIST
Mark English

Four separate photos were assembled
and output as a 16- by 20-inch print.
The assembled print was then drawn
upon and scanned conventionally.

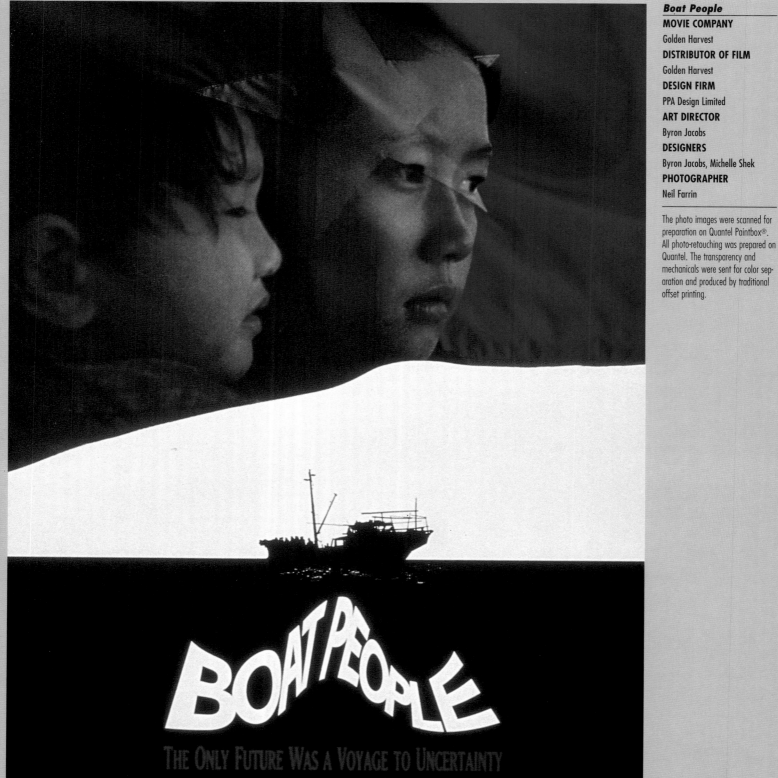

Boat People

MOVIE COMPANY
Golden Harvest
DISTRIBUTOR OF FILM
Golden Harvest
DESIGN FIRM
PPA Design Limited
ART DIRECTOR
Byron Jacobs
DESIGNERS
Byron Jacobs, Michelle Shek
PHOTOGRAPHER
Neil Farrin

The photo images were scanned for preparation on Quantel Paintbox®. All photo-retouching was prepared on Quantel. The transparency and mechanicals were sent for color separation and produced by traditional offset printing.

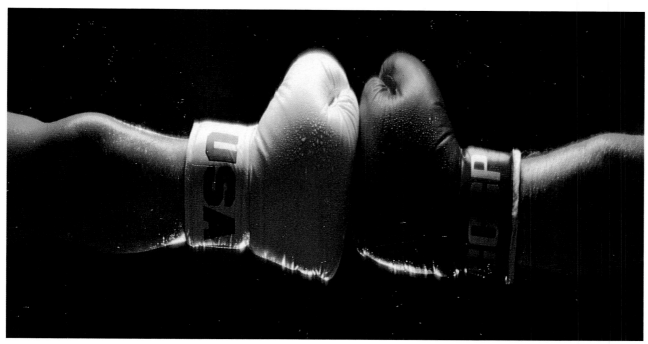

Rocky 10, trailer and television graphic

MOVIE COMPANY
MGM

DISTRIBUTOR OF FILM
MGM

DESIGN FIRM
Mike Salisbury Communications Inc.

ART DIRECTOR
Mike Salisbury

DESIGNERS
Sylvester Stallone, Mike Salisbury

To create the image of exploding gloves, designers used actual boxing gloves that were cut to plaster gloves and exploded with dynamite.

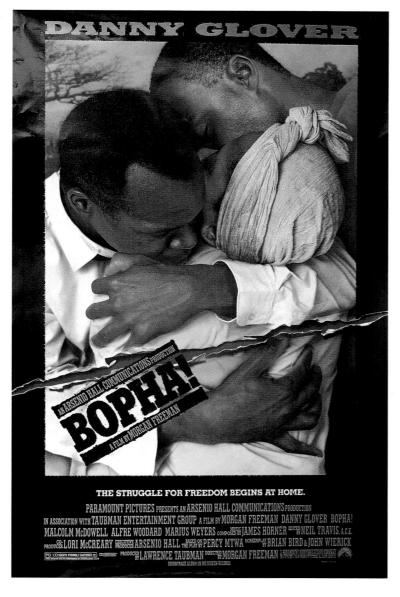

Bopha!

MOVIE COMPANY
Paramount Pictures

DISTRIBUTOR OF FILM
Paramount Pictures

DESIGN FIRM
BLT & Associates Inc.

ART DIRECTOR
BLT & Associates Inc.

DESIGNER
BLT & Associates Inc.

PHOTOGRAPHERS
Albert Watson, Pete Tangen

DIGITAL IMAGING
Digital Transparency

The designer added a special hit of red and gold to this six-color piece.

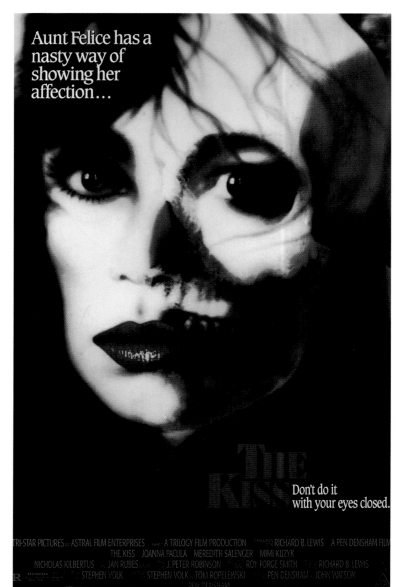

Aunt Felice has a nasty way of showing her affection…

Don't do it with your eyes closed.

The Kiss

MOVIE COMPANY

TriStar Pictures

DISTRIBUTOR OF FILM

TriStar Pictures

DESIGN FIRM

Mike Salisbury Communications Inc.

ART DIRECTOR

Mike Salisbury

DESIGNER

Mike Salisbury

ILLUSTRATOR/ARTIST

Jeff Wack

Three photographs were stripped together and painted by hand for this piece.

Aliens

MOVIE COMPANY

Twentieth Century Fox

DISTRIBUTOR OF FILM

Twentieth Century Fox

DESIGN FIRM

Mike Salisbury Communications Inc.

ART DIRECTOR

Mike Salisbury

DESIGNER

Mike Salisbury

PHOTOGRAPHER

Unit

ILLUSTRATOR/ARTIST

Terry Lamb

Three different photographs were stripped together and painted by hand for this image.

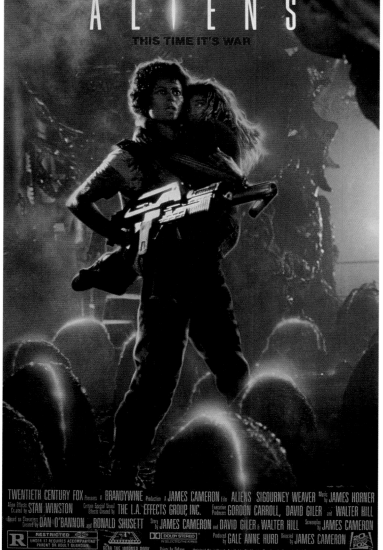

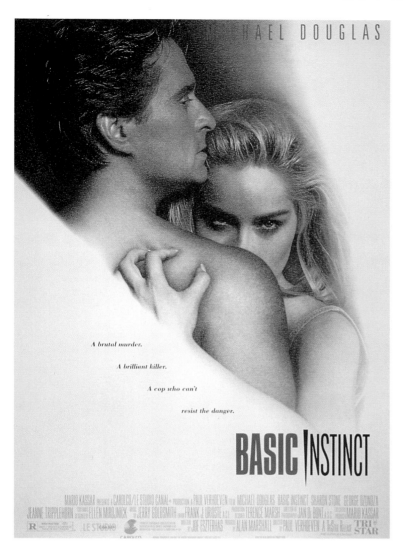

Basic Instinct, poster

MOVIE COMPANY

TriStar Pictures

DISTRIBUTOR OF FILM

TriStar Pictures

DESIGN FIRM

Mike Salisbury Communications Inc.

ART DIRECTOR

Bill Lopez

DESIGNERS

Mike Salisbury, Jeff Bacon

The heads of the actors were
stripped onto body-double photos
from a sketch concept.

Murder to Order

MOVIE COMPANY

Golden Harvest

DISTRIBUTOR OF FILM

Golden Harvest

DESIGN FIRM

PPA Design Limited

ART DIRECTOR

Byron Jacobs

DESIGNERS

Byron Jacobs, Michelle Shek

PHOTOGRAPHER

Richard Whitfield

The title art was hand-created and the
photographic image was produced tra-
ditionally. The designers merged the
two during color separation.

DESIGN DIRECTORY

B.D. Fox & Friends, Inc. Advertising
1111 Broadway
Santa Monica, CA 90401

BLT & Associates, Inc.
844 N. Seward Street
Hollywood, CA 90038

BRD Design
6525 Sunset Boulevard, 6th Floor
Hollywood, CA 90028

Canadian National Film Board
James Bentley
2l45 Cresent
Montreal, Quebec, H3G-2C1
CANADA

Dawn Patrol
3767 Overland Avenue, Suite 115
Los Angeles, CA 90034

The Dyment Company
531 Atlas Avenue
Monterey Park, CA 91755

Frankfurt Balkind Partners
6135 Wilshire Boulevard
Los Angeles, CA 90048

Gramercy Pictures
9247 Alden Drive
Beverly Hills, CA 90210

Jim Langman Illus.
6784 Laird Avenue
Reynoldsburg, OH 43068

JJ&A
205 South Flower Street
Burbank, CA 91502

Karyl Klopp Design
5209 8th Street
Charlestown, MA 02129

Margo Chase Design
2255 Bancroft Avenue
Los Angeles, CA 90039

Mike Salisbury Communications, Inc.
2200 Amapola Court
Torrance, CA 9050l

Misha Design
1638 Commonwealth Avenue, Suite 24
Boston, MA 02135

Muller & Company
Angela Coleman
4739 Belleview
Kansas City, MO 64ll2

Platinum Design
14 West 23rd Street
New York City, NY 10010

PPA Design Limited
69 Wyndham Street
7/F, Central, HONG KONG

Primo Angeli, Inc.
590 Folsom Street
San Francisco, CA 94105

30sixty design, Inc.
2801 Cahuenga Boulevard West
Los Angeles, CA 90068

Tracy Sabin Graphic Design
13476 Ridlen Road
San Diego, CA 92129

Yesh!
Yehudith Schatz
33 Yehudith Boulevard
Tel-Aviv, Israel

INDEX